IMAGES
of America

AROUND LAKE ARIEL

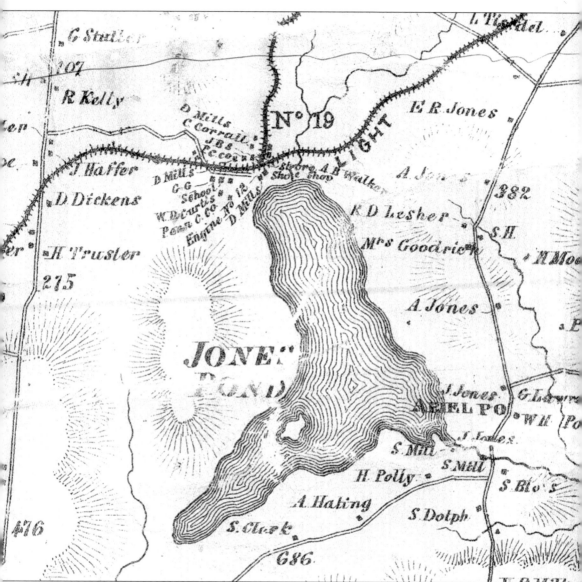

MAP OF JONES POND, 1860. This map was taken from the map of Wayne County drawn from entirely new and original surveys under the supervision of G. M. Hopkins Jr. It was published by C. E., M. S. and E. Converse Publishers, Nos. 517, 519, and 521, Minor Street, Philadelphia, in 1860.

On the cover: Pictured is Lake Ariel as it is seen from Fisherman's Landing. This photograph is No. 11 in *Original Photo. Souvenir of Lake Ariel*, published by Louis Hensel, Hawley, Pennsylvania, around 1895. (Courtesy of Lake Ariel Region Historical Association.)

IMAGES
of America

AROUND LAKE ARIEL

Kurt A. Reed
for the Lake Ariel Region
Historical Association

ARCADIA
PUBLISHING

Published by Arcadia Publishing
Charleston SC, Chicago IL, Portsmouth NH, San Francisco CA

Printed in the United States of America

Library of Congress Catalog Card Number: 2006927853

For all general information contact Arcadia Publishing at:
Telephone 843-853-2070
Fax 843-853-0044
E-mail sales@arcadiapublishing.com
For customer service and orders:
Toll-Free 1-888-313-2665

Visit us on the Internet at www.arcadiapublishing.com

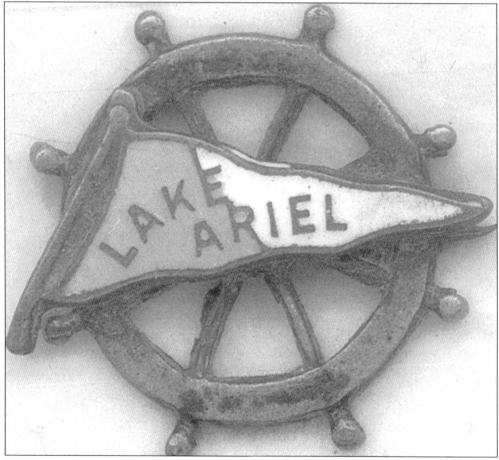

LAKE ARIEL REGATTA PIN. The first Lake Ariel Regatta was held on July 4, 1890, under the auspices of the Scranton Rowing Association. The pin is made of bronze and enamel.

CONTENTS

ACKNOWLEDGMENTS

The Lake Ariel Region Historical Association, a nonprofit organization, was formed in 2003 as a result of the increased interest shown by the area residents and summer vacationers in the history of the area that once was a thriving recreational destination and is still a summer vacation haven for cottagers.

As more and more people were willing to share their memories and information about the past, including their old pictures, the idea for a book of pictures highlighting the area was formed. Interested area residents searched their attics and storage areas for photographs and other items that would add to the existing collections. The people who contributed are the descendants, sons, daughters, and friends of the people who settled and built around Lake Ariel, forming the history of the village and surrounding area. We would like to thank those people who generously granted permission to reproduce their unique pictures. Without these pictures, the book would not have been possible.

Our contributors are Rev. Philip Altavilla, Dr. Walter Barbe, Joan Ramble Belles, Fred Birmelin, Sharon Birmelin, Rosanne Clauss, Tim Clauss, Joan Cobb, Gerald Conklin, Gertrude Conklin, Elaine Franc Cook, John Czubowicz, Kay Olivia Brown De Carvalho, Janet Dickinson, Marjorie Edwards, Wayne Edwards, Florence Gunster Feyder, Frank Feyder, Charles Frisbie, Leigh Gillette, Eleanor Heater, Elizabeth Hennessey, Paul Howe, Anita Santoro Joyce, Cora Sue Kobesky, James Kobesky, Lackawanna County Historical Society–The Catlin House, Alfred Lombardi, Sal Mecca, James J. Moffat, Janet Colvin Nicholson, Jeri Leverich Prussia, Kurt Reed, Calvin Samson, Dorothy Eno Samson, Fred Schweinsburg, Nancy Conklin Schweinsburg, Jerome Scott, Margaret Scott, Doris Simons, Beryl Swingle, Carole Woehrle, Randy Woehrle, and Arland Zeiler.

We hope we have not missed anyone, and if we have, we apologize and want you to know we appreciate your contributions.

INTRODUCTION

This book, about the people of the Lake Ariel area, had its beginning in 1954, when I, eight years old at the time, made my first trip to Lake Ariel. What a wonderful place this was in those days. My mind started collecting images of Lake Ariel from day one. The best memories of the early years include Brown's Cider Mill in operation on Franc Road, Ted and Harry Franc at the sawmill, Wildwood Lake as a large mud hole because a hurricane breached the dam, and taking a picture of my aunt in a six-foot hole dug by the floodwaters coming out of Lake Ariel. My earliest history lessons on the town and the park came from the Brown family, who had been involved in the operation of the park. I had arrived just in time to see the park, ride some of the rides, and then see it close and end what had been the golden years of the town.

As time and circumstance brought my family into the village, lots of new sights and characters became part of the memories of this collector of images: Joe Serafin at the beach; Hick Polley and Bud McCoy at the barbershop/pool hall; Joe Collins at his grocery store and Carl Patterson at his grocery store; the Samson family, who had been here forever, provided my best friend, Bill.

Our residence in the town was the old movie theater and restaurant. What a neat and historic place to call home for several years. Next door to the restaurant was one of the oldest businesses in town, Wayne Body Shop.

Everybody walked to the new Lake Consolidated School built in 1936. In the 1950s, kindergarten through 12th grade was all housed in one building. Ed Jenkins and Laverne Merritt ran the school.

The town was filled with a mixture of multigeneration families and characters who were attracted to the park during its years of operation. The little boy in the Samson and Samson Mercantile picture was a grown man who loved to play pinball machines. For those of you old enough, try out this list of names: Lester Seeley, Butch Wester, Norbert Heater, Chet Woodruff, Leigh Frisbie, Cap Ammerman, John T. Howe, Harry Ramble, Ed Davis, Kendall Jones, Red McDonald, Bayne Fields, Rudy Gershey, Roy Howe, Bill, Joe, and Cal Samson, Bowser Black, Chip Lombardi, Harley Bishop, and the Swingle brothers at their mills.

When the park closed, it became an unofficial playground and hangout for the local teenagers such as myself, Larry Heater, Bill Samson, and Tom Wilson. Every ride was explored, and the brave (dumb) even walked the abandoned and dangerous Cyclone.

In the 1950s, there was still freight service from the railroad, and the train came down the siding into town at least once a week. The freight station was still manned part-time into the 1970s. The Gravity Railroad bed was still clear enough to walk by the local Boy Scout troop and

other hikers. The rail bed wound through what are three different large developments today. The stone walls of one of the stationary engines is a vivid memory of this old Scout.

The intensity of the memories dies down and the years roll by; the person who would eventually write the history portion of this book is born and starts his collection of memories. Kurt Reed's collection of memories is in the form of old photographs, newspaper accounts, and old papers from generations of this town. Kurt and I came together once fleetingly in the 1970s, when he endured a half-year science course that I was teaching.

Somewhere in the late 1990s, it dawned on me that a lot of the old-timers that I knew, who were in possession of the best anecdotes and pictures about this town, were dying off. It was time to do something about preserving our local history. A computer and scanner were purchased, and it was time to start. My first contributor was John Czubowicz, who had a collection of about 50 pictures. I learned how to scan, enlarge, and re-expose electronically. Shortly after this time, I was steered back to Kurt Reed for additional pictures. He had hundreds of pictures, and months of spare time were spent saving his and many other contributors' pictures. The picture group grew until we were nine in number and formed ourselves into the Lake Ariel Region Historical Association. As soon as the group formed, we started showing our picture collection at annual history slide shows. The number one question at every show was, "Are you going to do a book?" After a few dead ends, we discovered Arcadia Publishing and its program to preserve local history. We were accepted for publication, and what you have before you is the end product of a very difficult process of weeding out great but unusable photographs and Kurt's huge effort to do the written history. If you, the reader, have any anecdotal material that goes with a particular picture, good or bad, write it down and send it to us. The information as presented has been verified, to the best of our ability, by newspaper reports published at the time and substantiated anecdotal information.

Fredric A. Birmelin
2006

One

EARLY SETTLEMENT

The Lenape-Monseys who camped and hunted along the shores of Lake Ariel were long gone by the time Wayne County was created in 1798. This land was Canaan Township's until 1808 and then Salem Township's until 1877 when it became Lake Township. A group of pioneers settled in the northern portion of the township prior to 1803. Elizur Miller and Eliphalet Flint were among these early settlers. Many of the next wave of settlers had the surname Jones. In 1791, Asa Jones married Mary Moore Polley, a widow with a son named Amos. The Jones family had moved from Hebron, Connecticut, in 1793 and arrived at Lake Township in 1803. Asa's brother Salman followed. Salman was elected sheriff of Wayne County in 1816. In 1822, Bethuel Jones and one of his sons-in-law, Lawrence Tisdel, also came from Hebron. Bethuel purchased the farm of Jonathan Watrous, who had purchased the property from Eliphalet Flint and Jesse Miller. The farm was then known as the Stock Farm for many years and is now known as the Lake Equestrian Center. The three Jones brothers and their children had, as the pioneers before them, settled in the vicinity of the southern tip, or outlet, of the lake. The land was fertile and comparatively free of large stones. Their farms and the lake were called Jonestown and Jones Lake (sometimes referred to as Jones Pond) in honor of these men. A dam was built across the outlet stream called Five Mile Creek, and sawmills were erected, as well as a school and a church.

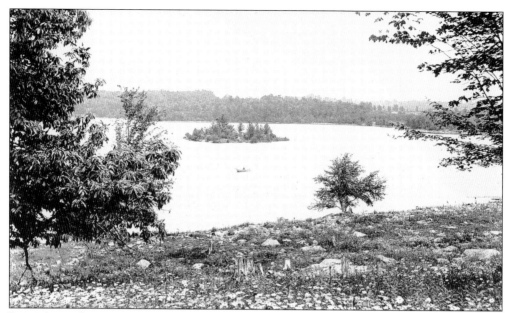

LAKE ARIEL (JONES LAKE) AND ROCK ISLAND. This view of the lake is how the early settlers must have seen it. The east shore was covered with hemlock and hardwood trees to the water's edge. The west shore had a forest fire that destroyed most of its timber. Rock Island is where many Native American relics were found, supporting the tradition that this was a favorite camping ground for the Lenape-Monseys. In 1893, Homer Greene published a book with the title *Dumman's Island*, changing the island's name forever.

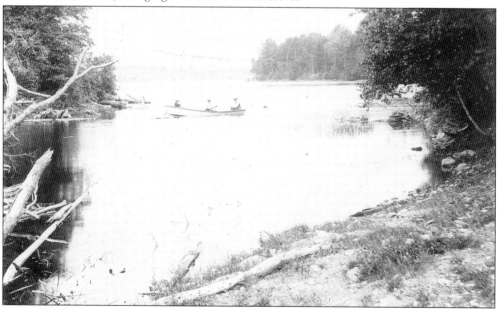

LAKE ARIEL FROM THE OUTLET. In early days, the lake had catfish and perch for the fishermen. In 1836, it was stocked with pickerel by some of the early settlers. Local legend states that it was not unusual in the early 1870s for several tons of pickerel to be taken through the ice in a single week. In 1875, it was stocked with bass by James A. Bigart. In 1877, it was stocked with landlocked salmon by S. L. Dart.

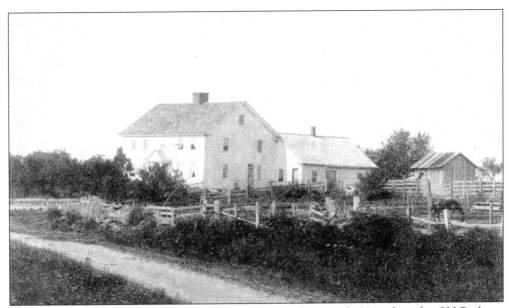

LAKE ARIEL STOCK FARM. The original house was built around 1801, when the Old Bethany Road was laid out; the road is currently named Stock Farm Road. The original house was moved back and turned when the main house was constructed in 1805. The central chimney had six fireplaces and a beehive oven with a capacity for 30 loaves. This was the oldest house in Lake Township until fire partially destroyed it. After architectural elements were saved, the rest of the building was demolished in 2000.

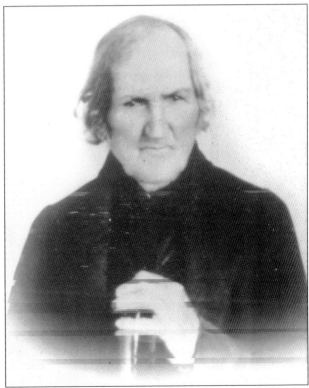

JEREMIAH OSGOOD (1761–1857). Jeremiah Osgood came to Pennsylvania from Connecticut in 1801. He settled on the southern boundary of Lake Township. Osgood had enlisted in the Continental Army in 1776, at the age of 14. He participated in the Battle of Germantown, spent the winter with George Washington at Valley Forge, and was later captured and held as a prisoner until 1778. He remained on active service until 1781. When Osgood was in his 90s, he had his photograph taken, becoming the only Revolutionary War soldier in the area to have his image preserved.

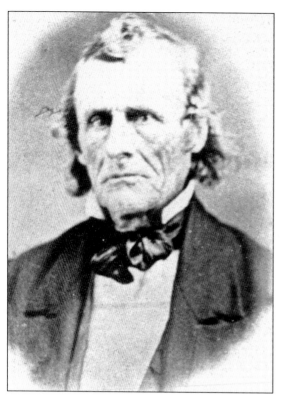

ELDER GEORGE DOBELL (1786–1867).
Elder George Dobell came from England in 1818 and settled in Sterling, Wayne County. In 1828, he was ordained as a Baptist minister and moved to Jones Lake. He became the first settler of the area called Chapmantown, today Avoy, in northeast Lake Township. In 1846, Dobell built the third and most efficient sawmill on Five Mile Creek, the outlet of Jones Lake.

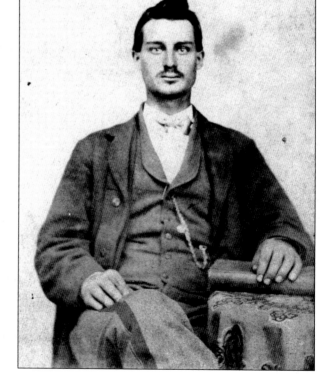

WILLIAM RAMBLE (1822–?).
William Ramble was a skilled millwright who came from Northampton County around 1847. He worked in his trade for many years in mills in and around Jonestown. Ramble married Frances Dobell (1825–1886), Elder George Dobell's daughter.

JOEL JONES (1803–1870). Joel Jones was the son of Deacon Asa Jones (1766–1843) and the widow Mary Moore Polley Jones, who were part of the first settlers in Lake Township. Jones married Delinda Purdy (1809–1890) and had five children, Byron, Collinda, Melissa, Reuben, and Polly. He was a farmer who supplemented his income as the postmaster of Ariel in 1858.

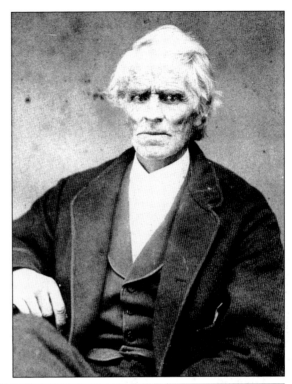

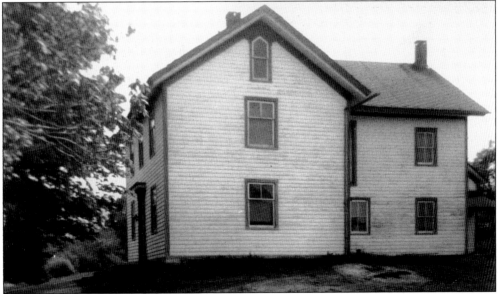

RESIDENCE OF JOEL JONES. This house stood where Avoy Road intersects Golf Park Road. This house was built about 1828 and became the post office in 1858. Since its establishment in 1851, the post office had been located at Plane No. 19 on the Pennsylvania Coal Company's Gravity Railroad at the northern end of the lake. Jones moved the post office to his home at the southern end of the lake. Jones and many of his family were Confederate sympathizers and flew the Confederate flag when the Civil War started. Pres. Abraham Lincoln removed Jones, and the post office moved back to Plane No. 19.

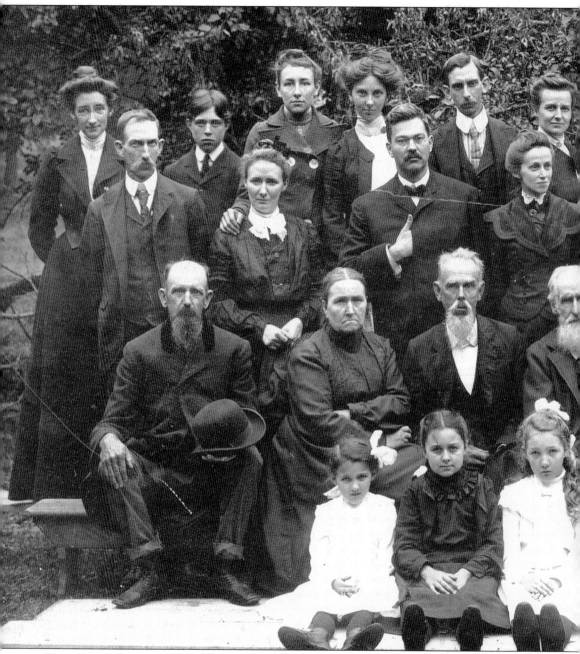

JONES FAMILY REUNION, 1903. This picture of the children, grandchildren, and great-grandchildren of the late Joel Jones was taken to commemorate the 100th anniversary of his birth. In the front row of adults are his surviving children and their spouses. Seen here are, from left to right, unidentified,

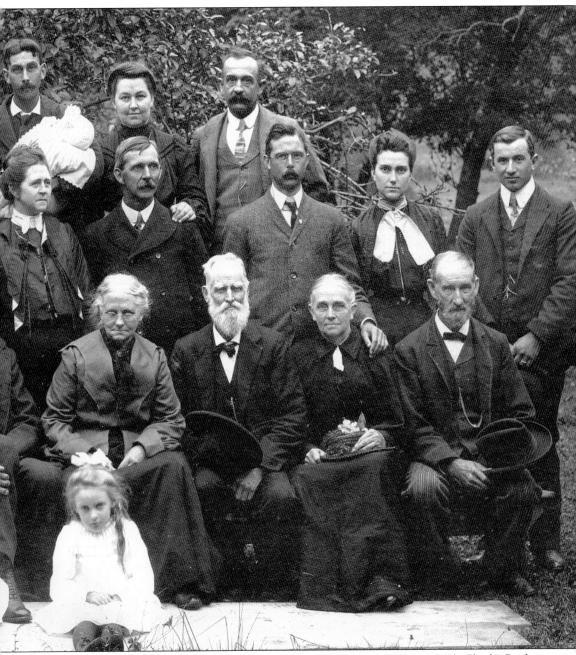

Abigail Cobb Jones (1848–1915), wife of Reuben Jones; Reuben Jones (1840–1912); Charlie Purdy, husband of Collinda Jones; Collinda Jones Purdy; Byron Jones (1829–1912); Polly Jones Bidwell (1844–1922), wife of William Bidwell; and William Bidwell (1840–1918).

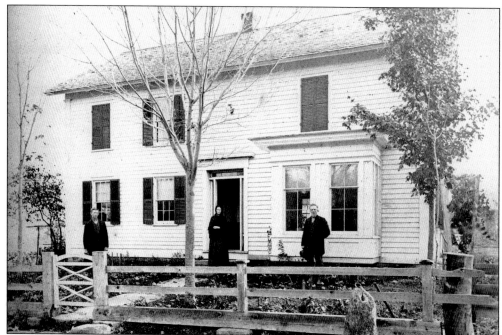

RESIDENCE OF BYRON JONES. Byron Jones was the oldest son of Joel Jones and Delinda Purdy Jones. Shown in this 19th-century image are, from left to right, Clarence Jones, son of Byron; Lucy Allen Jones (1843–1886), wife of Byron; and Byron Jones (1829–1912). Byron was an early justice of the peace for Lake Township. The house still stands today off of State Route 191, south of the lake, and is owned by Dorothy May Wilson Wooten.

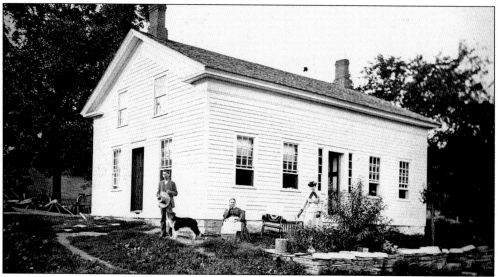

RESIDENCE OF EMORY E. JONES (1831–1923). Emory E. Jones built this house on today's Stock Farm Road in 1860, when he married Arabella Helen McKane. Emory worked as a fireman at Plane No. 18 on the Gravity Railroad. He and his wife had eight children, of whom none ever married. In this photograph, it is thought to be, from left to right, Curtis E. Jones (1867–1926), who became a local photographer; Arabella Jones (1842–1923); and one of their daughters, Anna Belle (1865–1881).

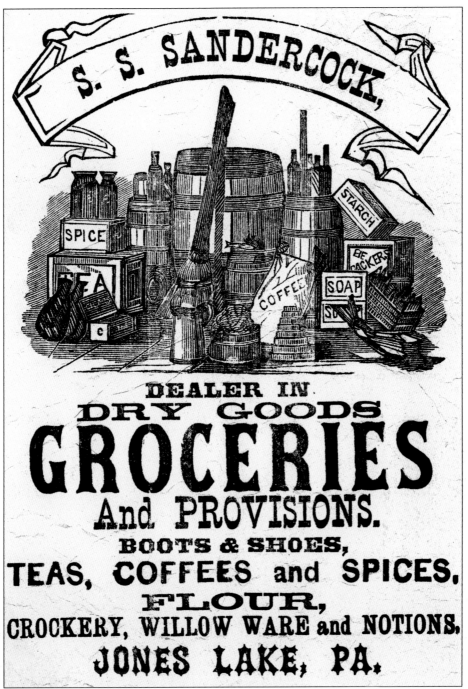

SANDERCOCK PAPER BAG, AROUND THE LATE 1870S. This rare piece of advertising came from the store of Susan Schenck (Greene) Sandercock. Sandercock was the daughter of Giles and Harriet Greene and the sister of Homer Greene, the famous author. When she was young, she learned the telegrapher trade and became an operator for the Pennsylvania Coal Company's Gravity Railroad at Plane No. 19. She married John N. Sandercock, also a storekeeper. The bag is marked with the original name: "Jones Lake, PA."

WOOL CARDING PARTY, 1921. The elderly women of the Jonestown settlement got together at the Vandervoort home in 1921, to see if they could still card and spin wool as they had in their youth. Seen here are, from left to right, Laura Collins (1841–1924), Sarah Hagerty (1839–1927), Arabella Jones (1842–1923), and Polly Bidwell (1844–1922).

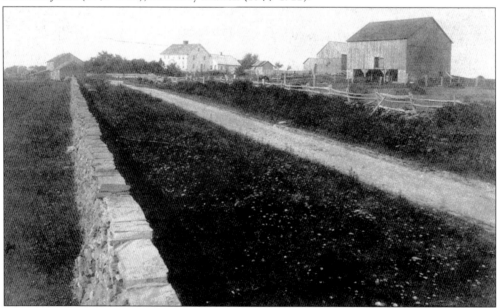

LAKE ARIEL STOCK FARM WALL. Elbert P. Jones (1842–1923) sold this farm in 1888 to the Scranton firm of Cleland, Simpson and Taylor. John Simpson took possession of the farm on April 1, 1889. In 1894, Levi A. Barhight and his son Charles started building a mile of stone wall at the farm. J. Tibbitts drew the stone from the nearby fields. The Barhights were still building the wall over a year later. This wall is no longer standing.

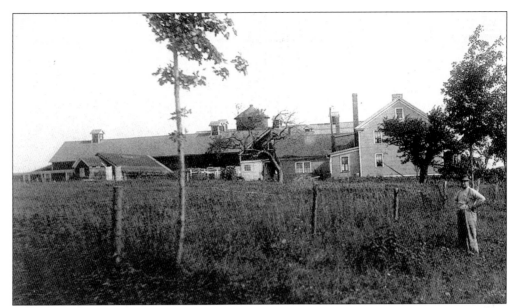

LAKE ARIEL STOCK FARM BARNS. In February 1918, the Simpson Stock Farm barns caught fire from sparks from a torch that was being used to thaw out a frozen pipe. By June 1918, John Simpson had replaced the burned barns with a large new structure. This photograph shows the new barns, farmhouse, and Stock Farm Road about 1920. These barns were destroyed by fire in 1962.

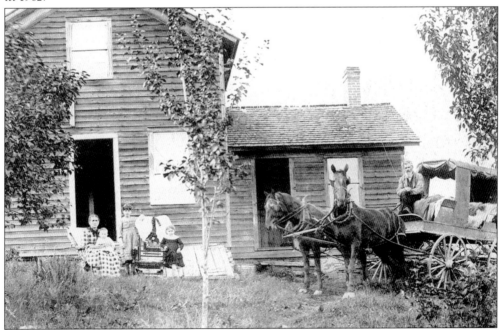

RESIDENCE OF DAVID EDWARDS. David Edwards (1839–1921) supplemented his income by starting a stage line transporting passengers and freight. Around 1885, Edwards poses with his wife, Lucinda Chapman (1839–1918), and children in front of their house. Edwards is sitting in the stagecoach, a crude-looking affair that appears to be a high wagon with hides thrown over the seats and canvas to roll down in case of bad weather.

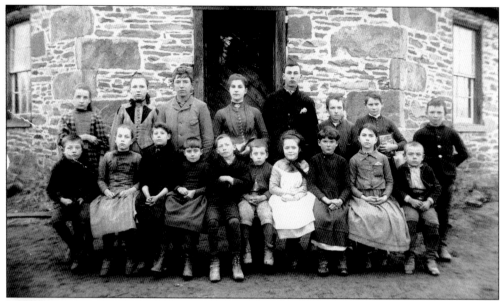

JONES LAKE OCTAGONAL STONE SCHOOL. The octagonal stone school was erected in 1851–1852 on the R. D. Lesher farm (today the home of Steve Lesher). Lesher made the woodwork and the Megargles of Sterling did the masonry. The Jones Lake Baptist Church was organized in 1854 and met in this school until its church was built in 1878, just down the road. This class photograph was taken about 1880.

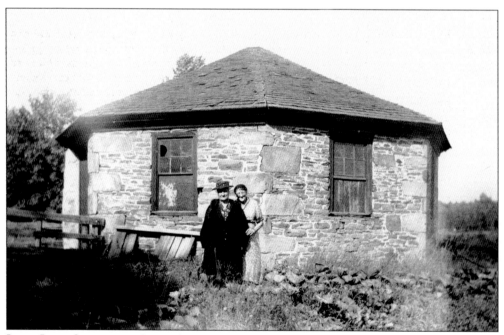

JONES LAKE OCTAGONAL STONE SCHOOL ABANDONED. By 1890, the school had been converted into a barn on the Lesher farm. This photograph, taken in 1939, shows two former students, Edith Vandervoort and Ella Elston. Notice the large quoins used in the construction of the corners of the building. The school was demolished in 1984.

Two

PENNSYLVANIA COAL COMPANY'S GRAVITY RAILROAD

James Archbald, as chief engineer, was responsible for locating and building the entire railroad from Port Griffith (on the Susquehanna River one mile below Pittston) to Dunmore, and then onto the juncture with the Delaware and Hudson Canal, at what would become the village of Hawley. On the Gravity Railroad, two different track beds were used, a loaded (or heavy) track for trains of cars carrying coal from the mines to the canal docks in Hawley and an empty (or light) track for trains of empty cars returning to Port Griffith.

The cars were hauled to the tops of a series of inclined planes by steam engines or waterpower and then released to coast to the bottom of the next plane. There were 12 planes on the heavy track and 10 planes on the light track. Between the planes, the track was referred to as the level, but in actuality, the heavy track descended 6 inches in every 60 feet, and the light track descended 6 inches in 54 feet. Plane No. 19 on the light track was located on the north shore of Jones Lake.

The group of farms known as Jonestown, on the southern side of the lake, was not destined to grow in size. The building of the Pennsylvania Coal Company's Gravity Railroad brought workmen, stores, and, in 1851, a post office named Ariel, after the airy spirit in Shakespeare's *The Tempest*, to the northern side of the lake. Jonestown faded from memory.

DWIGHT MILLS (1819–1894).
Dwight Mills was raised in
Carbondale. When he was 18,
he went to New York City to
study the machinist's trade.
After three years in the city, he
returned to Carbondale and in
1848 became a civil engineer
on the Pennsylvania Coal
Company's Gravity Railroad.
By 1851, he moved his family to
Plane No. 19. Superintendent
John B. Smith promoted him
in 1854 to master mechanic,
having charge of all machinery
from Plane No. 12 (Gravity
Railroad) to Hawley on the
heavy track, and from Hawley
to Plane No. 21 (Wimmers area)
on the light track.

ALSON VANDERVOORT (1827–1910).
Alson Vandervoort came to the
area in 1847 from Newark. In 1848,
Vandervoort went to work laying
track on the Gravity Railroad. When
the road opened in 1850, he was
promoted to car runner. By 1885, the
Gravity Railroad was abandoned, and
he ended his career by removing the
rails. He was the only person from
Lake Township to have worked on the
Gravity Railroad from start to finish.

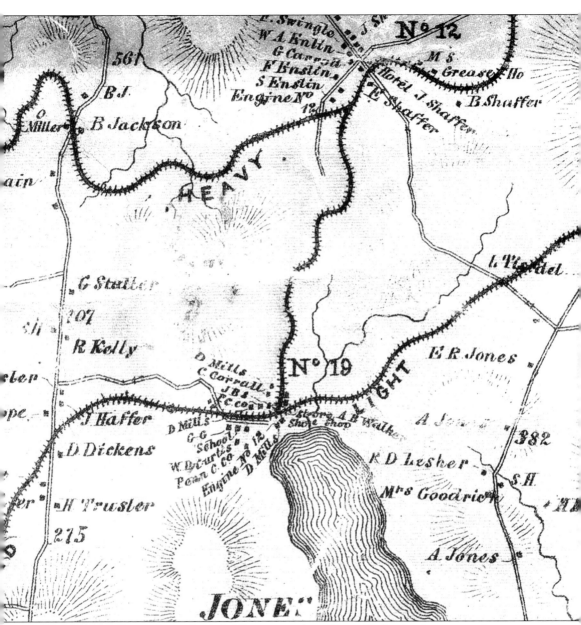

PLANE NO. 19/JONES LAKE (1860). The present-day village of Lake Ariel owes its existence to the building of the Pennsylvania Coal Company's Gravity Railroad. The town grew up around Plane No. 19 on the light track. It was an important station, being midway between Dunmore and Hawley, and also the terminus of the branch, or switchback, road that lead from Plane No. 12 through Plane No. 19. The area around Plane No. 12 is still known as Gravity.

Ariel, Pa., *Sept 24* 1867

M Salem School Dist

FLOUR, FEED
AND
MEAL

NET CASH on DELIVERY

Bought of CURTIS & EVANS,

GENERAL DEALERS IN

DRY GOODS, GROCERIES, HATS, CAPS, BOOTS, SHOES,

FLOUR, FEED MEAL AND PROVISIONS, also PATENT MEDICINES DRUGS, DYE STUFFS, &c.

Terms Cash or 30 days.

No. 19 Penn. C. Co.'s R. R.

1	Zinc Coal Hod for No 12		1.75	
	Paid Freight on Books		2.24	$3.99
	Rec'd Pay			
	Curtis & Evans			
	To making Bench Turnpike School hous			
	by Benjamin Jackson 12/—			1.50
				5.49

CURTIS AND EVANS BILLHEAD. This billhead is dated September 24, 1867. It contains the two early addresses of the village of Lake Ariel: "Ariel, Pa." and "No. 19 Penn. C. Co.'s R. R."

FAIRVIEW HOTEL. The first hotel at Plane No. 12, or as it was known locally, Gravity, was opened by John Shaffer (1819–1892) in the early 1850s. Charles A. Masters bought the hotel in 1870. He built a new hotel, seen in the foreground, which is attached to the old Shaffer Hotel in the background. This rare photograph shows the Gravity Railroad passenger cars in front of the hotel, on the switchback to the light track, going toward Jones Lake. The hotel was razed in 2005.

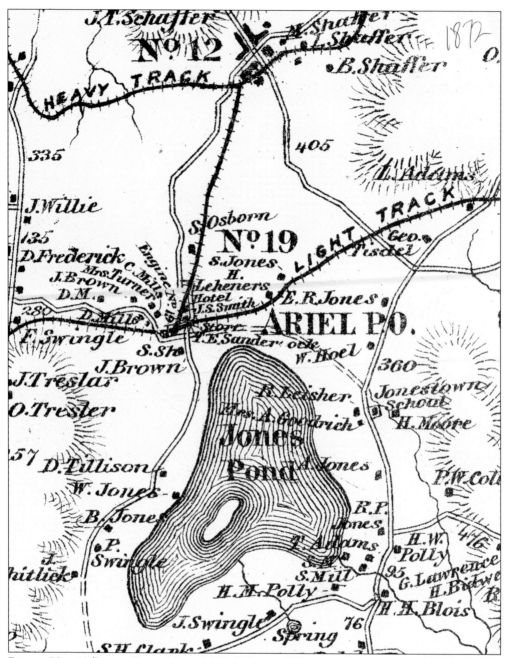

PLANE NO. 19/JONES POND MAP, 1872. What a difference 12 years can make. Since the first map in 1860, names have changed to the next generation, and the railroad has brought prosperity in the form of businesses and a hotel. The increase in local traffic has prompted the building of a new road on the west side of the lake. State Route 191 somewhat follows this old wagon track. Jones Pond was on its way to becoming Lake Ariel, the resort.

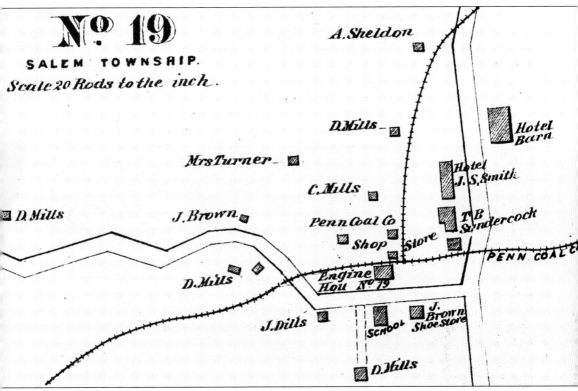

A. Sheldon

D. Mills

Mrs Turner

C. Mills

D. Mills

J. Brown

D. Mills

Penn Coal Co

Shop Store

Engine Hou Nº 19

J. Dills

School

J. Brown Shoe Store

D. Mills

Hotel Barn

Hotel
J. S. Smith

T B Sundercock

PENN COAL CO

CLOSE-UP OF PLANE NO. 19, 1872. The road coming in from the left is Tresslarville Road. Shortly after 1872, this road will continue through the intersection to become Main Street. The road on the top right goes to Plane No. 12 (Gravity), and on the bottom right, the road leads to Hamlin. The buildings marked "Penn Coal Co" in the center are today the site of St. Thomas More Church. J. S. Smith's hotel is the site of the Lake Elementary School, and J. Brown's shoe store is Tom Howe's house.

LAKE ARIEL AND VILLAGE, AROUND 1874. This rare photograph, listed as "Birds eye view of Ariel Lake, No. 19 Plane," was taken by L. Hensel around 1874, making it the earliest-known picture of the area. Looking south, with the lake in the background, the buildings are, from left to right, a hotel barn, a switchback railroad from Plane No. 12, a small shed, Dwight Mills's

house (behind Mills's house, the peak of Smith's Hotel can be seen), Sandercock's house with a tree in front, the Greene homestead (center), Engine House No. 19 (to the right of the tall trees), and the Gravity Railroad shop area (in front of smoke and stack).

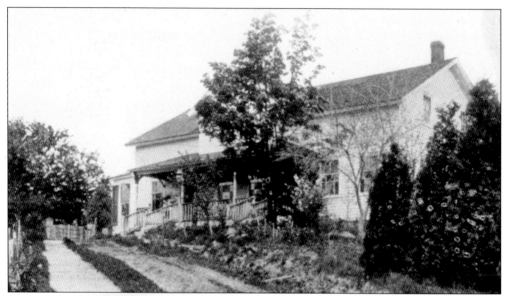

GREENE HOMESTEAD, LAKE ARIEL. In 1848, this was the first house erected in what was to become the village of Lake Ariel. It was built near the Gravity Railroad, at the foot of Plane No. 19. The first occupant was a man by the name of Wilcox, but late in 1850, Giles Greene, newly appointed engineer in charge of Plane No. 19, moved in with his wife.

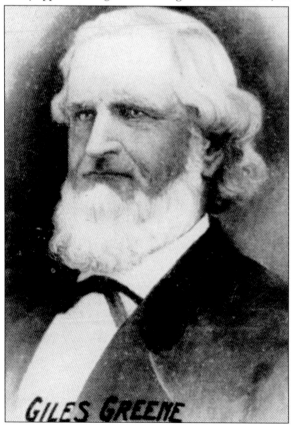

GILES GREENE

HON. GILES GREENE (1823–1892). Giles Greene married Harriet Schenck on September 21, 1850, in Cherry Ridge Township. On November 18, 1850, he escorted her to the only frame dwelling in the clearing of Plane No. 19. In 1861, Greene was appointed postmaster of Ariel, and in 1864, the Gravity Railroad made him general lumber agent. In that capacity, he had charge of the purchase, manufacture, and shipment of wood used by the railroad in the building of its coal breakers and in the opening of its mines. Greene was elected in 1876 as an associate judge of Wayne County.

HOMER GREENE (1853–1940). Lawyer, poet, and author Homer Greene was the son of Giles Greene and Harriet (Schenck) Greene. Homer was born at Lake Ariel. In his early years, Homer worked as a telegraph operator in Pittston and was a member of the Corps of Civil Engineers. Both jobs were for the Gravity Railroad. Homer wrote *Dumman's Island, A Story of Lake Ariel,* and the book was sold for many years in Lake Ariel Park.

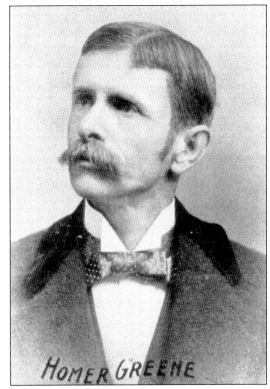

HOMER GREENE

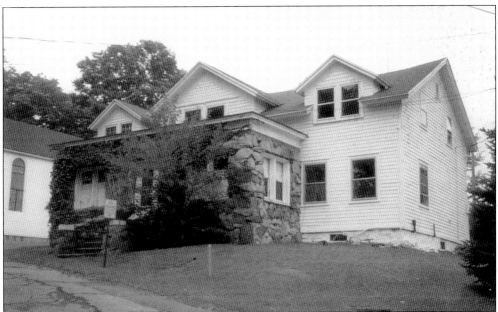

ST. THOMAS MORE RECTORY. This was the former Greene homestead. After Harriet Greene died, the house passed to her grandson Homer Sandercock. Sandercock added the stone porch and two small dormers. In 1940, he and his wife, Dorothy, sold the property to Bishop William J. Hafey for the formation of a Catholic mission. The rectory was torn down around 1996 for the church expansion.

Nov 26th _____ 1882

M͞ O. G. Allen

TO PENNSYLVANIA COAL COMPANY, DR.

For transportation from _____ Hawley _____ to _____ N⁰ 19

4 Crates Wood in Shape				1 70	
1 Bx Castings 7 Racks 1 Desk					
	N.Y.L.E. & W.		6 96	8 6	
to Drawing from Nineteen				1 5	
				10 1	

Received payment for the Pennsylvania Coal Company.

Chas E Mills

PENNSYLVANIA COAL COMPANY BILLHEAD (1882). This load of freight was sent from Hawley to Plane No. 19 (Lake Ariel). It is signed by Charles E. Mills, son of Dwight Mills.

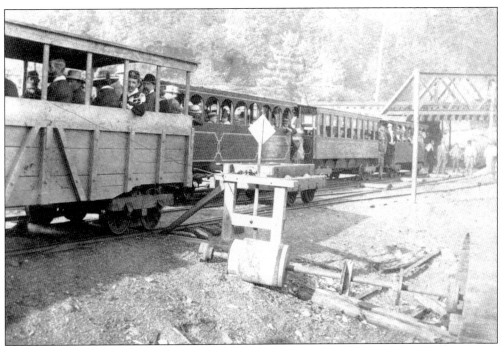

EXCURSION TRAIN AT PLANE NO. 6. As early as 1874, the Gravity Railroad was advertising the advantages of an excursion to Jones Lake: "the pure bracing mountain air invigorates and refreshes the entire system." The advertisement went on to say, "Trains will leave the foot of Number 6 [Dunmore shown here] every morning at 7:30 and return in the afternoon, giving excursionists from four to five hours at Jones Lake. Fare, one dollar and fifty cents for round trip."

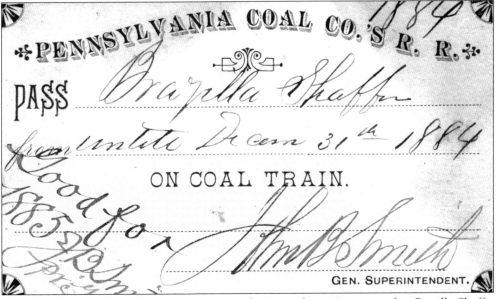

GRAVITY RAILROAD PASS. This rare pass to ride "on coal train" was issued to Brazilla Shaffer (1821–1899). Shaffer was the first settler of Plane No. 12 (Gravity). The Gravity Railroad did not want people riding on the coal trains, preferring them to wait for passenger cars. This rare pass shows that exceptions were made.

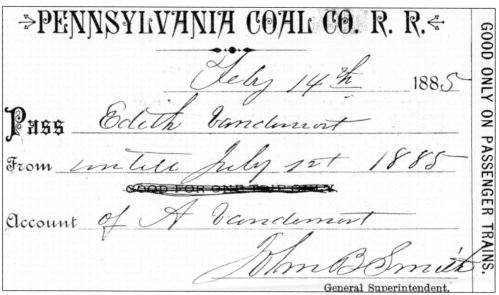

GRAVITY RAILROAD PASSENGER PASS. This pass was issued to Edith Vandervoort (1864–1964) because her father, Alson Vandervoort, was a car runner for the Gravity Railroad. The pass is dated from February 14 to July 1, 1885, the last months of operation of the railroad.

CULM EMBANKMENT ON TRESSLARVILLE ROAD. This photograph is of Amzi B. Cook (1890–1958), Lake Ariel undertaker, taken in his front yard with his matched team. The background shows the culm embankment for Plane No. 19. The stone abutment that would have been on the uphill side has been taken down, and the large stones have been recycled. The building in the background is the Ariel Lumber Company, today the site of the Agway building.

Three

THE ERIE AND WYOMING VALLEY RAILROAD

The Erie and Wyoming Valley Railroad was the successor to the Pennsylvania Coal Company's Gravity Railroad. The steep hills and long descending valleys of the Gravity Railroad would be too much grade for the heavy steam locomotives. When the new rail route was mapped out, the tracks were located quite a distance down the hill from where Plane No. 12 had been.

With the abandonment of the Gravity Railroad, Jones Lake had a big problem. For the first time in 35 years, the town was without a railroad. This caused a large loss of excursion business. The excursion problems were solved on April 4, 1886, when the Jones Lake Railroad Company was organized to construct a spur rail from the Erie and Wyoming Valley Railroad to the lake. It was incorporated on September 5, 1887. The Erie and Wyoming Valley Railroad leased the spur on January 3, 1888.

The popularity of Jones Lake as a resort went beyond expectations. Boardinghouses and hotel accommodations were being added to. Steamers and rowboats were plying the lake waters. One newspaper article recounts a Fourth of July when 10,000–12,000 people came on the train to the lake. In 1893, the railroad station was moved closer to the park, and a turnaround was built for the train. In 1894, the spur rail was merged into the Erie and Wyoming Railroad, and then further merged with the Erie Railroad in 1898.

The Erie Railroad provided passenger service to the lake until 1934 and freight service for about another 30 years. Most of the evidence of the railroad's existence is now gone.

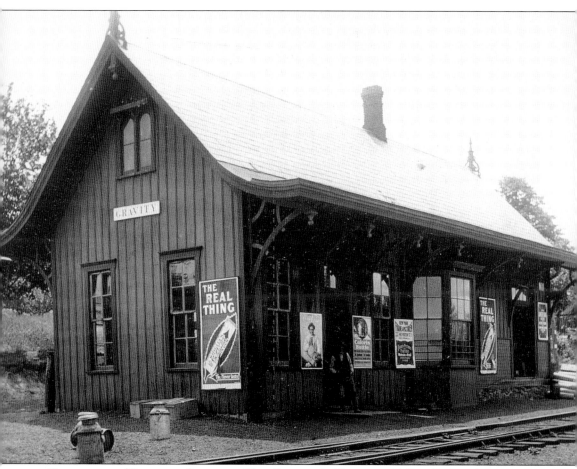

GEORGETOWN/GRAVITY STATION. The Erie and Wyoming Valley Railroad station at Georgetown was built in February/March 1885. This station was just below Cobb's store. By 1910, when company photographer J. E. Bailey was sent out from the Erie Railroad to take the photograph shown here, the name of the station had been changed to Gravity. In January 1937, the station caught fire. The late Francis Damato, who worked at Cobb's store said, " It was early morning, we called Wayne Swingle the track foreman to flag down the 4 AM coal train because of the fire." The station was not rebuilt.

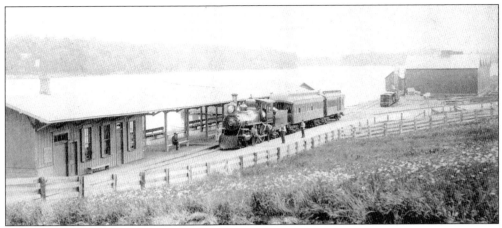

JONES LAKE RAILROAD DEPOT. This photograph shows the Jones Lake Railroad depot leased by the Erie and Wyoming Valley Railroad. The depot was built in 1888 and used until 1893 on this site. Beyond the covered platform behind the train is the first boathouse where the original steam launch was kept. The large buildings to the right are the five icehouses of the Consumers' Ice Company of Scranton.

ORIGINAL PHOTO. SOUVENIR

OF

LAKE ARIEL.

Published by L. HENSEL,

HAWLEY, PA.

COVER OF SOUVENIR OF LAKE ARIEL, AROUND 1895. Louis Hensel, famous Wayne County photographer, put together this *Original Photo. Souvenir of Lake Ariel* about 1895. The books contain between 12 and 14 photographs of Lake Ariel, taken from 1885 to 1894; no two books are the same. The next 13 photographs were taken by Hensel for these souvenirs, and the titles are his.

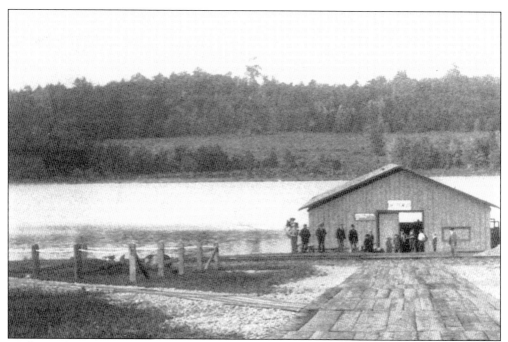

THE BOATHOUSE SEEN FROM THE PICNIC GROUNDS. This boathouse was built in April 1888 and measured 80 feet by 40 feet. It was designed to house the original steam launch. A boathouse was built on the lake as early as 1875, but its location is not known. In the background is the east shore, and to the left, just out of the photograph, is the Jones Lake depot. The depot's covered platform, which would connect it to the boathouse, has not yet been built.

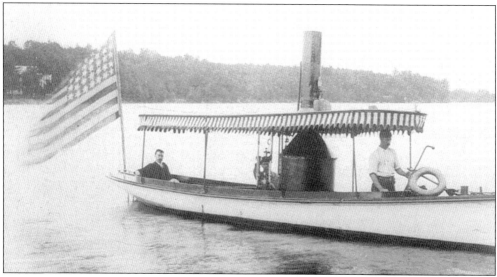

THE LAKE ARIEL STEAMER. The screw-propelled steamer *Janet* was purchased in Philadelphia in October 1887 by Dwight and Charles E. Mills. The steamer was shipped through Hawley on April 20, 1888, on a flatcar of the Erie and Wyoming Valley Railroad, on its way to Lake Ariel. Three days later, it was launched on a trial trip around the lake. It was 30 feet in length and had a stationary covering to protect passengers from sun and rain. In 2003, the 1887 steamer became the logo of the Lake Ariel Region Historical Association.

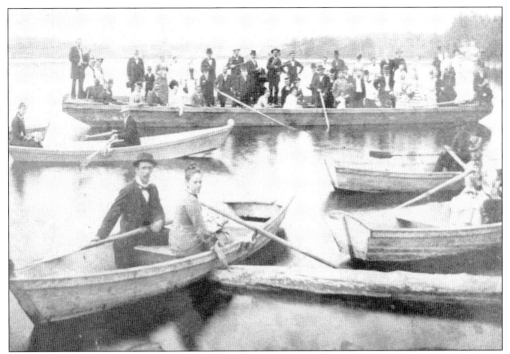

THE LAKE ARIEL BARGE. The steamer held only 25 people, so to accommodate another 60, the Millses built this barge in May 1888. This barge was towed around the lake behind the steamer. This image, taken by Louis Hensel, is one of only two known photographs of the barge.

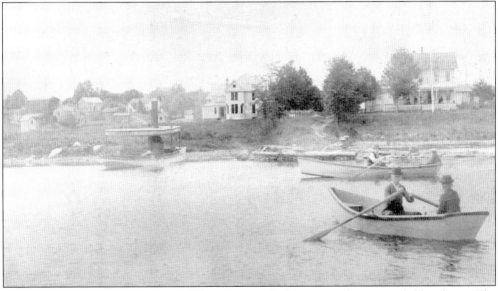

THE LAKE HOUSE BOAT LANDING. This photograph shows a combination of old and new. The buildings on the extreme left are remnants of Plane No. 19, from the Gravity Railroad days. The other buildings to the left of Maple Avenue are, from left to right, the engine house, the shop, the Greene house (partly behind the stack of the steamer), and the Dart house (now the Kwiateks'); to the right of Maple Avenue is the Lake House. The new steamer and rowboats show the prosperity brought by the Erie and Wyoming Valley Railroad.

THE LAKE HOUSE. The Lake Side Hotel was built by Spencer Leroy Dart and completed in March 1880. The building stood on the corner of Maple Avenue and East Shore Drive. The name was soon changed to the Dart House, after its owner. Dart sold the lake and the hotel to Charles E. Mills on July 15, 1887. Under Mills's ownership, the hotel became the Lake House.

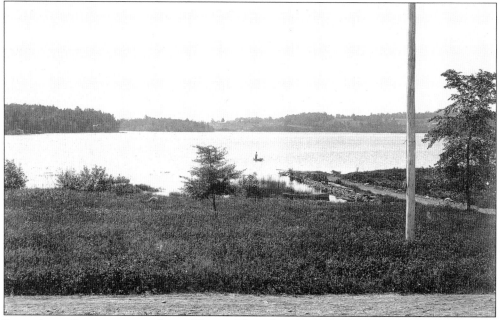

LAKE ARIEL SEEN FROM THE LAKE HOUSE. This advertisement appeared in a local newspaper on June 5, 1890: "The Lake House is now under the management of A. J. Keyes. Board from $8 to $12 per week, including boat and lake privileges. The scenery is grand; and the air is pure; good water and the best rowing and fishing, and no 'sketers.'"

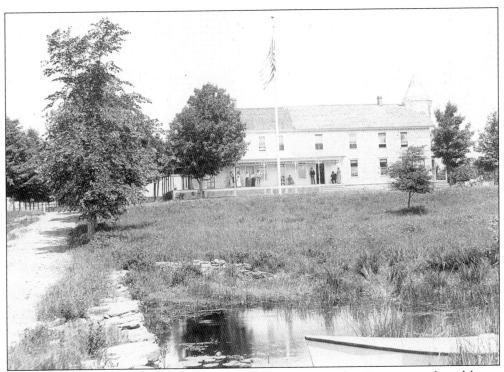

THE LAKE HOUSE (AFTER 1892). In November 1892, the Lake House was enlarged by an addition that measured 30 feet by 60 feet, with a tower. Notice on the left that Maple Avenue goes to the water's edge.

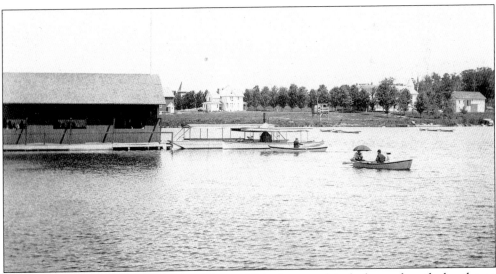

STEAMBOAT LANDING AND THE LAKE HOUSE. This photograph is the last to show the boathouse or landing on its original site on the west shore. Built in 1888, it was removed to the north end of the lake in 1894. Anchored in front are the steamer and the barge. In the background is Spencer Leroy Dart's house and the Lake House and its barn.

THE DRIVE TO THE PINES.
The drive to the Pines is now East Shore Drive. The Pines was an early hotel built on the east shore of the lake.

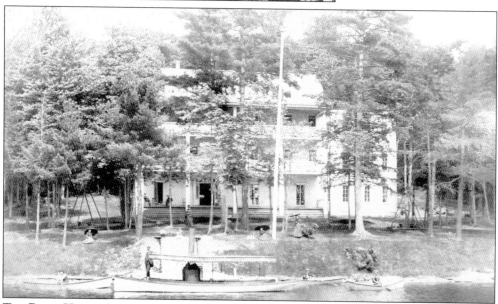

THE PINES HOTEL. In a grove of pine trees on the east shore, Spencer Leroy Dart built a picnic grove in the late 1870s. By 1883, he had erected this hotel in his grove; it took its name, the Pines, from the trees. The building measured 60 feet by 120 feet and was three stories high. It was the largest building on the lake at the time. The hotel's heyday was during the time of the Erie and Wyoming Valley Railroad. It stood until 1914, when it was replaced by the Schadt Cottage, which is today owned by the Scotts.

LAKE ARIEL FROM THE OUTLET. Notice the steamer in the center of the photograph.

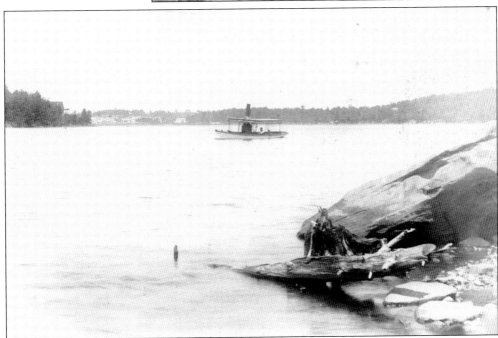

LAKE ARIEL SEEN FROM ROCK ISLAND. To the left of the island is the steamer; in the background is the village of Lake Ariel.

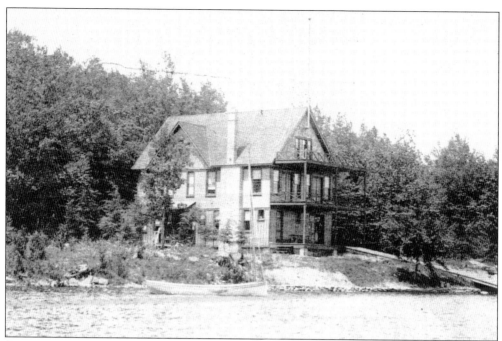

SCRANTON ROWING ASSOCIATION. The clubhouse of the Scranton Rowing Association was built in 1889, on the west shore of Lake Ariel. In later years, locals called the building the Ariel Club.

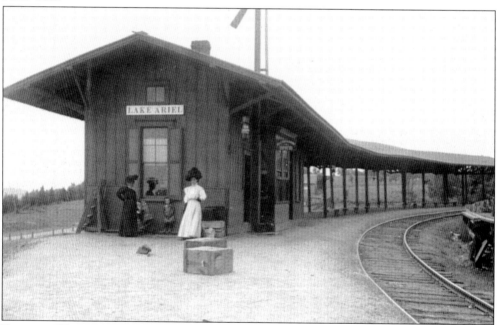

ERIE AND WYOMING VALLEY PASSENGER STATION. In April 1893, the original Jones Lake depot was moved from the proximity of the west shore of the lake across the tracks and road to a higher location, nearer to the park. Added at the same time was a circular track (in right of picture) to turn the trains around so that they did not have to back up the 1.7 miles to the main line. In 1895, the Jones Lake Railroad was taken over by the Erie and Wyoming Valley Railroad.

ERIE AND WYOMING VALLEY RAILROAD TICKET. This return ticket from the lake to Scranton is dated September 20, 1894. In 1887, Jones Lake had officially become Lake Ariel, but seven years later, this ticket is still stamped with "Jones Lake" on the back.

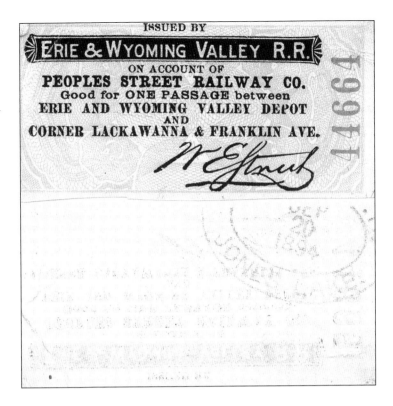

ISSUED BY
ERIE & WYOMING VALLEY R.R.
ON ACCOUNT OF
PEOPLES STREET RAILWAY CO.
Good for ONE PASSAGE between
ERIE AND WYOMING VALLEY DEPOT
AND
CORNER LACKAWANNA & FRANKLIN AVE.

44664

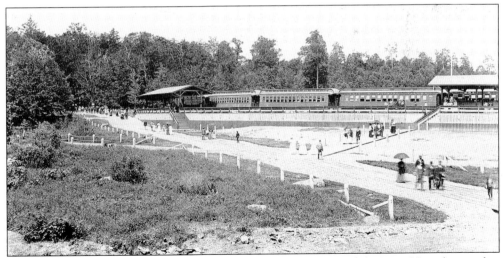

LAKE ARIEL R.R. DEPOT AND PIC-NIC GROUNDS. This photograph by Louis Hensel is another from *Original Photo. Souvenir of Lake Ariel.* The photograph title and its spelling are his. This is the earliest view of the covered platform at the circle, as seen from the lake.

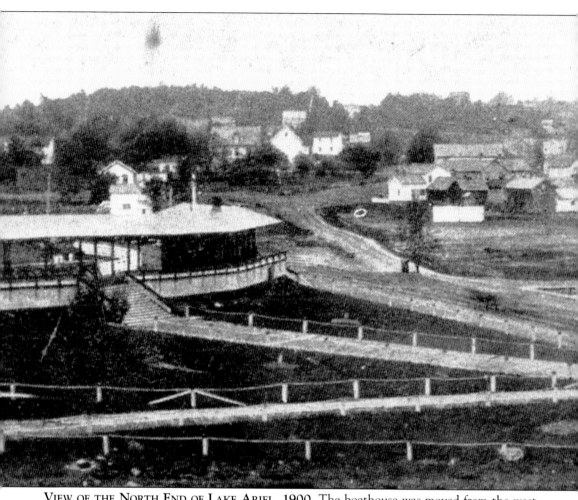

VIEW OF THE NORTH END OF LAKE ARIEL, 1900. The boathouse was moved from the west shore to the north shore in 1894, and two more were built shortly after. In the center of the

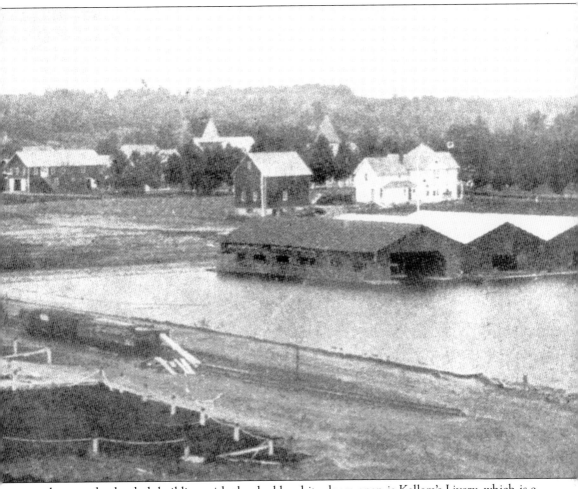

photograph, the dark building with the double white doors open is Kellam's Livery, which is a restaurant today.

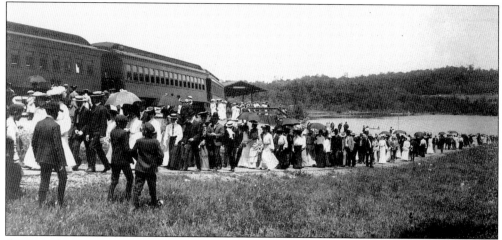

SUMMER CROWDS GOING TO THE PARK. This photograph, taken by local photographer Curtis E. Jones, proves the newspaper accounts. The *Honesdale Citizen* of July 5, 1882, states, "The Erie and Wyoming Valley Railroad ran nine extra trains each way and all crowded on the 11th . . . the number on the ground was estimated at 10,000 to 12,000."

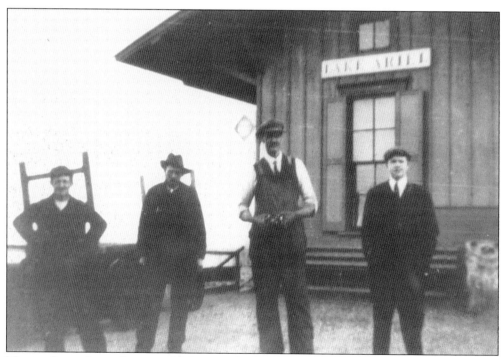

MEN AT LAKE ARIEL STATION. Unfortunately the names of all but one of these men have been lost to history. The tall man, third from the left, is Curtis E. Jones (1867–1926), the Lake Ariel photographer who, from 1894 until 1925, took many of the photographs used in this book.

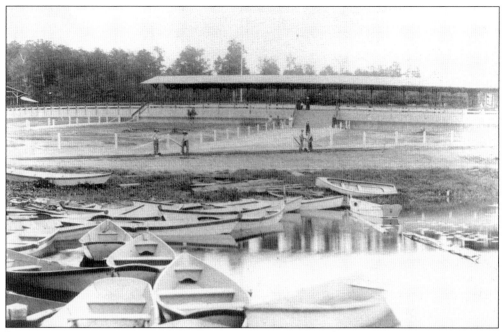

RAILROAD PLATFORM SEEN FROM THE WEST SHORE. In the foreground are some of the 75 rowboats, built in Philadelphia, that could be rented. The boats were shipped to Lake Ariel on the train.

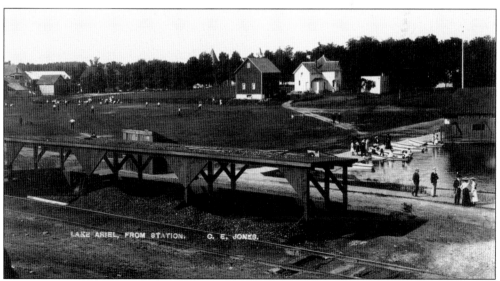

LAKE ARIEL FROM STATION. This photograph, taken by Curtis E. Jones, shows the coal-loading docks in front of the station. Note the baseball game on the field.

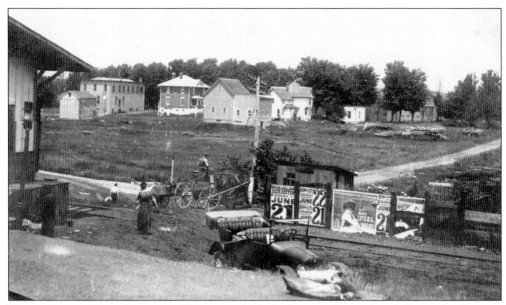

VILLAGE FROM TRAIN STATION. This view of Maple Avenue shows, from left to right, Samson and Cook Mercantile, Roy Howe's house, A. J. Keyes's barn, A. J. Keyes's house, the Lake Ariel Post Office, and the Lake House barn. The Lake House was destroyed by fire in 1916. Compare this photograph with the previous one; notice the piles of lumber at the corner of Maple Avenue and East Shore Drive.

PEOPLE BOARDING TRAIN. These people are boarding the Erie Railroad train behind the present-day Agway. In the background is H. A. Swingle's feed mill. The trains stopped here with freight for the mills along Tresslarville Road and students for the Lake Ariel School.

Four

LAKE ARIEL PARK

The oldest picnic grove at Jones Lake belonged to Dwight Mills. This site was to become Lake Ariel Park. The first known description of the park comes from the *Honesdale Citizen*, dated July 29, 1875. It reads in part, "Sloping up westerly from the lake are the pic-nic grounds of Mr. D. Mills . . . These grounds have been recently improved at considerable expense . . . In the centre of the grounds is the well built pic-nic hall, affording ample room for 300 people . . . around these buildings in triangular form are three beautiful springs . . . utilized in the culture of trout. This is the best spot for pic-nicing we have ever seen and it well deserves its increasingly large patronage."

In 1894, Dwight Mills passed away. His son ran the park for three years and then sold out to a group of Scranton businessmen who formed the Lake Ariel Improvement Association. In 1908, after 11 years of operation by this group, Lake Ariel Park closed for the first time since its inception in 1875.

By the 1920s, the park was reopened and rebuilt by a group headed by Floyd E. Bortree. The park saw its heyday under Bortree, who added many rides and attractions. Bortree died in September 1946, and the park passed into the hands of F. Burton Derby (Bortree's son-in-law).

The end was in sight now. Buildings fell into disrepair, shows and acts were not rescheduled, and the grounds grew up. In 1953, Derby moved to Florida and sold the park to A. J. Schrader. Joe Serafin ran the park until it was shut down by a series of summer hurricanes and winter heavy snows. The assets of the park were sold off in 1956.

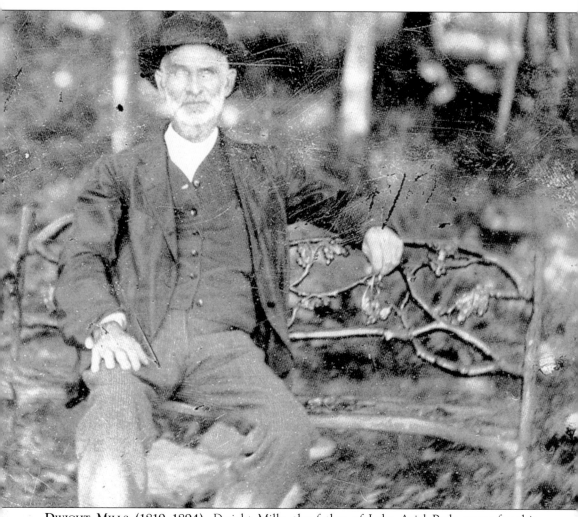

DWIGHT MILLS (1819–1894). Dwight Mills, the father of Lake Ariel Park, poses for this photograph, which may be the earliest ever taken in the park. Notice the fancy iron bench.

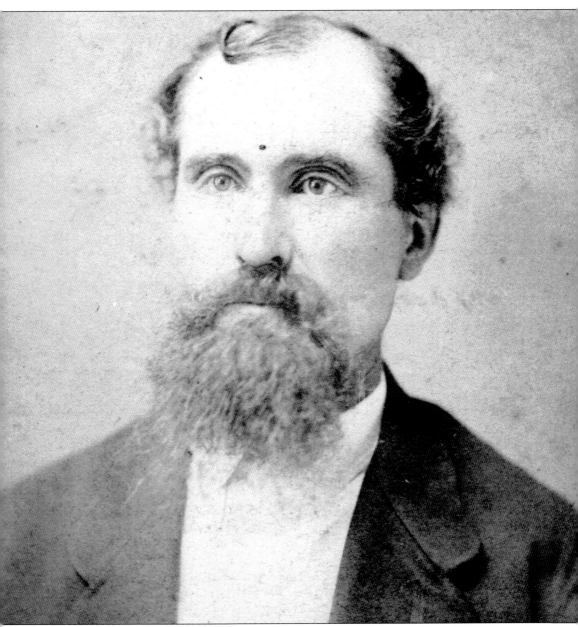

SPENCER LEROY DART. Spencer Leroy Dart was the proprietor of the second park, Dart's "Pic-nic" Grove on the east shore of Lake Ariel.

ELLEN SWINGLE DART.
Ellen Swingle, daughter of Simon and Elizabeth Swingle, married Spencer Leroy Dart. They lived in South Canaan until 1875, when her father bought Jones Lake for them from Dwight Mills.

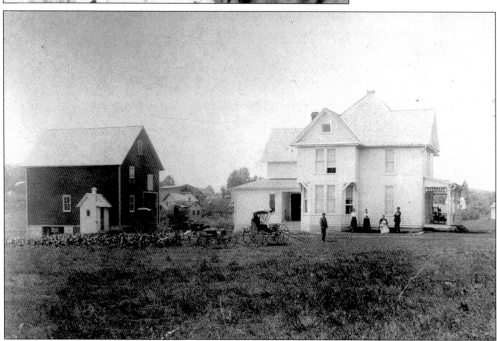

DART'S HOME, LAKE ARIEL. Spencer and Ellen Dart built this home on Maple Avenue in the village. Today it is owned by the Kwiatek family.

SWING IN THE "PIC-NIC" GROVE. This early photograph is the only known close-up image of Dart's Grove on the east shore. In later distant views of the Pines Hotel, the swings can also be seen. One wonders where the ladies went, as this view shows only men.

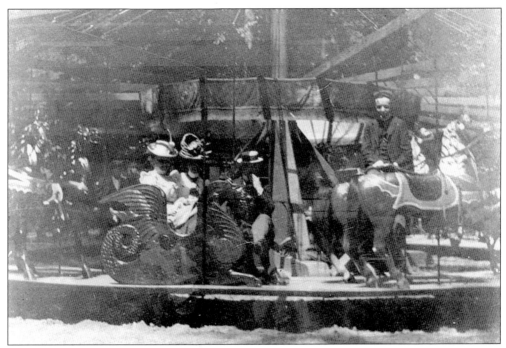

MILLS'S PICNIC GROVE MERRY-GO-ROUND. The first merry-go-round came to Lake Ariel in July 1888. This rare photograph is thought to be of a simple, portable standing-horse platform carousel attributed to Gustav Dentzel of Philadelphia around 1885. Note the real horsehair tail.

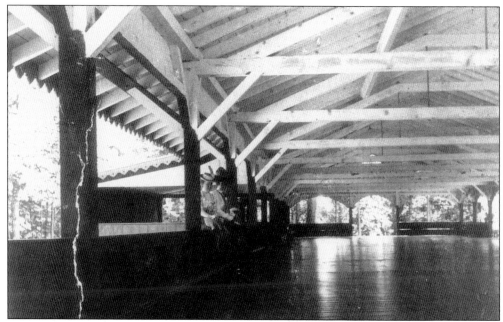

DANCING PAVILION IN THE PARK. This pavilion was built by Charles E. Mills in May 1888 and measured 40 feet by 70 feet. In 1897, the Lake Ariel Improvement Association purchased the lake and park. In the same year, it added an additional 100 feet on to the dancing pavilion, making it 170 feet in length. Dancing in the park must have been extremely popular because by 1900 the building had grown to 40 feet by 200 feet. Floyd E. Bortree built a new dance pavilion in 1927.

REFRESHMENT STAND AND DANCING PAVILION. The refreshment stand is in the foreground. "Coffee Cakes Candies Nuts Soft-Drinks" is painted under the eaves. The dancing pavilion is in the background on the right. Also on the right, note the wooden benches built around the trees. This photograph was taken in 1900.

56

GROUP OF YOUNG MEN. The reason for this photograph has been lost to history, but the names of most of the boys have not. Shown here are, from left to right, (first row) Floyd E. Bortree (1877–1946) and Sid Polley; (second row) Ray Simons, ? Johnson, Uri Evarts, unidentified, and Leslie Simons. This is the earliest-known photograph of Floyd E. Bortree, who owned Lake Ariel and the park from 1926 until his death in 1946.

ATHERTON BORTREE (1907–1921). Atherton, or "Buddie," as he was known, was the only son of Floyd E. Bortree and Anna C. Kirby Bortree (1879–1950). Atherton had one sister, Alene, who became the wife of F. Burton Derby.

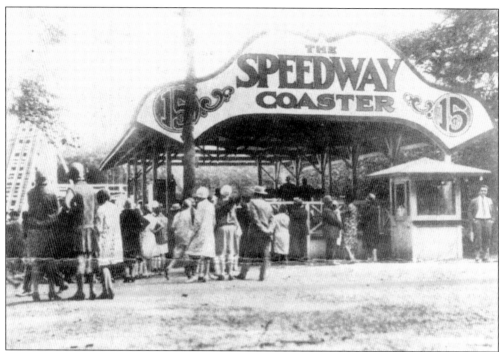

THE SPEEDWAY COASTER. The roller coaster of Lake Ariel Park was built between November 1928 and May 1929. The designer was the Miller Speedway Coaster Company, and the builder was Oscar Bittner of Allentown. A newspaper stated that the cost of the coaster was "of about $50,000," but the contract price of the coaster was $24,000. In the late 1940s, the Speedway Coaster was rebuilt. Sources claim that a Mr. Hoover from the Philadelphia Toboggan Company supervised the reconstruction. At the same time, the name of the coaster was changed to the Cyclone. It ran until the park closed.

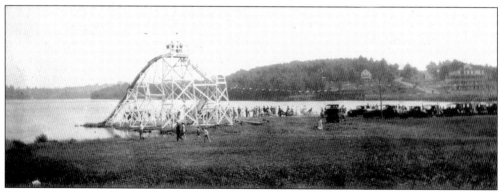

WATER TOBOGGAN SLIDE. This slide was on the Lake Ariel beach but was not ready for Floyd E. Bortree's first Fourth of July in operation, in 1927. By the opening of the 1928 season, the slide was listed with the many other attractions. On the right in this view is the Hotel Columbia, later called the Lake Ariel Hotel.

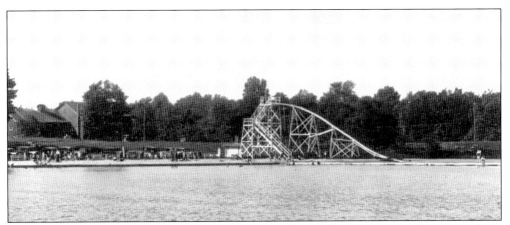

WATER TOBOGGAN SLIDE VIEWED FROM THE LAKE. Floyd E. Bortree "spread the bathing shore with a generous supply of [sea] sand [from New Jersey], making an ideal swimming place." The swimming area is seen on the left. In the background is the Lake House barn.

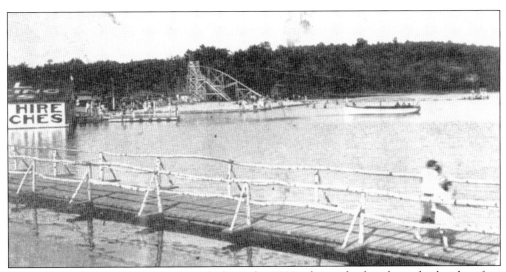

LAKE ARIEL BEACH. This photograph from the 1930s shows the beach at the height of its popularity. The sign on the boathouse on the left reads, "Bathing Boats for Hire, Ice Cream Soda Lunches." Note the boardwalk from the beach to the park. The water toboggan slide is seen in the background.

NATURE'S WONDER SPOT
LAKE ARIEL PARK *and* BEACH

Swimming

ater Toboggan and Accessories

Boating

Rowboats and Launc

ALL AMUSEMENTS
Including Northeastern Pennsylvania's most thrilling roller coaster

AEROPLANE RIDING
Brand new ship, Wright Whirlwind powered

OPEN EVERY DAY

O PARK ENTRANCE CHARGE FREE AUTO PARKI

LAKE ARIEL PARK
AND BEACH

LAKE ARIEL PARK ADVERTISEMENT, 1929. This advertisement was published in the *Lackawanna Motorist*, volume 10, No. 7, July 1929. Notice the box in the advertisement for "Aeroplane Riding, Brand new ship, Wright Whirlwind powered."

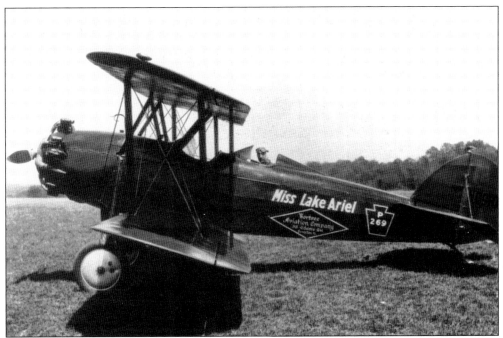

MISS LAKE ARIEL. Floyd E. Bortree had an aviation field open in Lake Ariel for rides by Memorial Day 1928. The field was located above the Hotel Columbia on the opposite side of present-day State Route 191. An advertisement for the park dated July 4, 1929, reads, "Thrills! Thrills! July 4th Lake Ariel Park and Beach Aeroplane Maneuvers, Parachute Jumping—Demonstration of the first new powerful ship of the Bortree Aviation Company . . . Miss Lake Ariel."

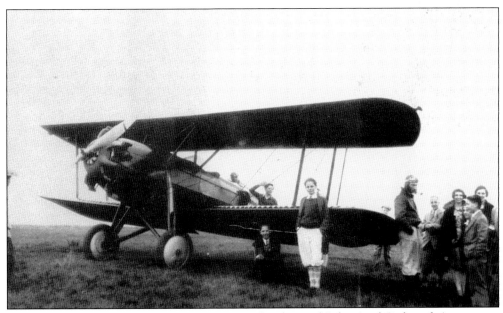

MISS LAKE ARIEL WITH PASSENGERS. A 1931 brochure of Lake Ariel Park and Amusement Company Inc., Scranton office, 318 Adams Avenue, stated on the back page, "Miss Lake Ariel, a government licensed plane and pilot operates every day carrying sightseers up through the clouds."

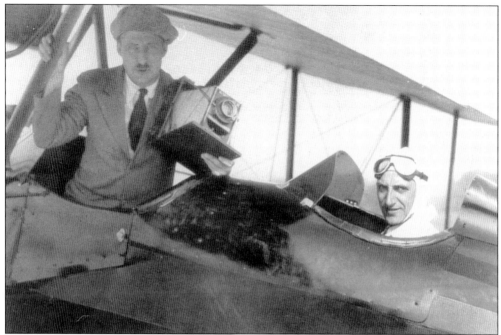

Miss Lake Ariel's Pilot with Photographer. Pilot A. H. Newman is shown here with an unknown photographer. An aerial view of the lake was on the cover of *Dumman's Island, A Story of Lake Ariel* by Homer Greene. The book was sold in the park for 25¢ in the 1930s.

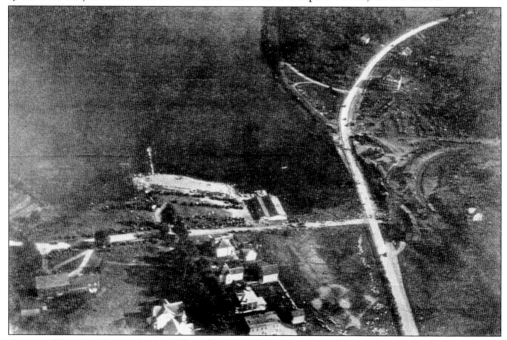

Aerial View of Lake Ariel. This photograph appeared in the brochure of Lake Ariel Park dated 1931. The caption reads, "Aerial View of the new concrete road approach to park entrance showing bathing beach and extensive automobile parking grounds. Photograph made from aeroplane Miss Lake Ariel."

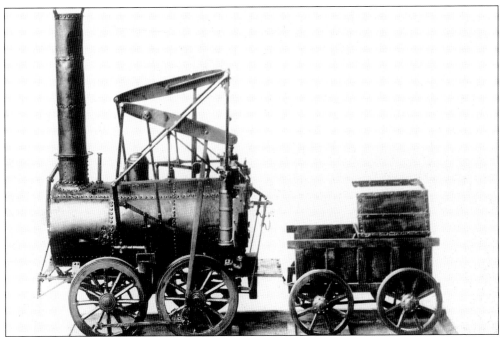

AVERY MODEL OF *STOURBRIDGE LION*. This model of the *Stourbridge Lion* (the first locomotive in America that made its trial run on August 8, 1829, in Honesdale) was made in 1931 by Norman Avery of Hoadleys. It was on display at Lake Ariel Park's penny arcade, which was built in 1928. When one put a nickel in the slot, it would run for over three minutes. After World War II, Avery removed it from the park and donated it to the Wayne County Historical Society.

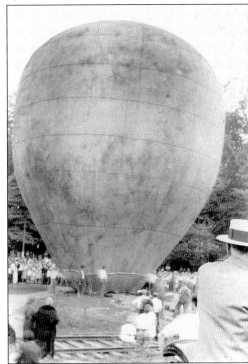

BALLOON ASCENSION AT LAKE ARIEL, 1931. The first mention of a balloon ascension at Lake Ariel Park was in August 1928, for the Wayne County Farmer's Picnic. The advertisement showed a balloon with a woman hanging upside down on a trapeze, holding an American flag. The woman was billed as "Ruby 'Reckless' Johnson, 22 year old girl, aeronaut and parachute jumper."

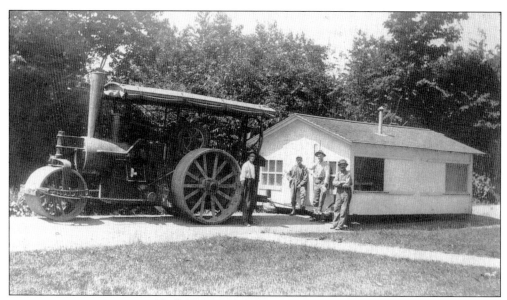

MOVING A PARK STAND, AROUND THE 1930s. Thomas Palmer (left), with the Lake Township steamroller, is shown with three helpers moving a stand in Lake Ariel Park. Palmer built the Clown Castle, the second fun house in Lake Ariel Park, in the 1940s.

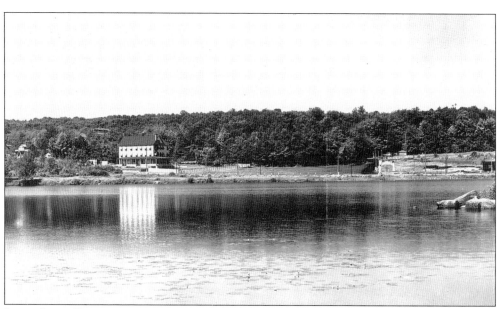

LAKE ARIEL HOTEL AND PARK ENTRANCE. In this view, taken in the late 1930s, are two of Lake Ariel's most famous landmarks. The Lake Ariel Hotel (built as Hotel Columbia in 1893) has towered over Lake Ariel for generations and was a popular gathering center in years past, when Lake Ariel Park (entrance shown on right) attracted thousands of visitors each summer.

LAKE ARIEL PARK AND BEACH
LAKE ARIEL, WAYNE COUNTY, PENNSYLVANIA

SCRANTON OFFICE: 204-206 MONROE AVENUE » » TELEPHONE 2-8391

Dec. 13, 1940.

To Whom it may concern:

Dear Sirs:

Miss Inez Curtis has been in our employment as a cashier for the summer months since 1935.

Our dealings with Miss Curtis have been very satisfactory. We have found her to be very efficient, honest and upright in character. We would highly recommend her for any position she might seek.

Very truly yours,

LAKE ARIEL PARK & AMUSEMENT CO.

BY _F. Burton Denby_

Pres.

FBD:Z.

LAKE ARIEL PARK AND BEACH LETTERHEAD, 1940. From 1927 through the 1930s, the park's Scranton office address was 318 Adams Avenue, but by 1940, the address was 204–206 Monroe Avenue. This letter of reference for Inez Curtis (1918–2005) states that she was a cashier from 1935 to 1940. Ten days after this letter (December 23, 1940), Curtis married Stanley C. Matthews (1916–1984), who was then a student at Harvard Law School.

CAROUSEL HORSE WITH MARGARET MALAKIN, 1943. These carousel horses (the second one is in the background on the left) were in front of attorney George O'Brien and Genevieve O'Brien's cottage, today Theodore and Linda Malakin's. The horses (now gone) are thought to have been part of the park's second merry-go-round, added to the park in 1891.

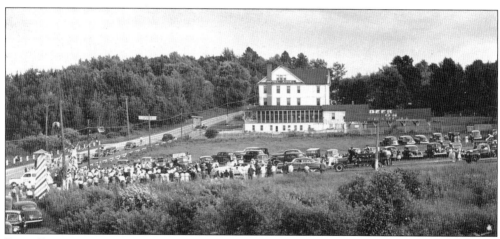

PARK ENTRANCE AND HOTEL, FIREMEN'S DAY, 1946. At the park's entrance were two tall, tapered wooden pylons painted with diagonal stripes, seen on the left in this view. Coming down out of the park is Lake Ariel's first Firemen's Day parade. This was on July 27, 1946. On the same day, the world's largest fire truck was exhibited in the park.

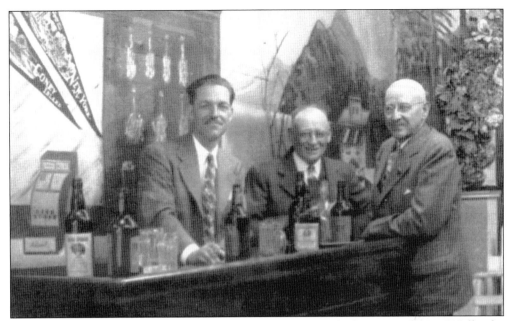

The Hotel Bar. Seen here are, from left to right, F. Burton Derby (1902–1966), "Pop" Hollander (1865–1952), and Floyd E. Bortree (1877–1946). Derby was manager and later president of Lake Ariel Park, Hollander kept the monkeys in Lake Ariel Park, and Bortree was the owner of Lake Ariel Park.

Frederick Burton Derby (1902–1966). F. Burton Derby, as he was known, was a news writer and columnist in Scranton and New York, director of physical education in the Scranton Public Schools, and active in the management of Lake Ariel Park. On June 22, 1927, he married Alene Bortree, daughter of Floyd E. Bortree and Anna C. Kirby Bortree. They had two children, Floyd B. Derby and Jacquelin Derby Kohlman Theobald.

HEY-DAY IN THE PARK, AROUND 1947. The Hey-Day and Dodgem (in background) were purchased by Floyd E. Bortree in 1928. The building on the right was the penny arcade. The girls in the car are Vera Reed Shaffer (left) and Muriel Ogden.

TICKET BOOTH AND PARK'S TRAIN TRACKS, 1948. In 1939, Richard Hettes of Hamlin built a one-fourth-scale model of an American Type passenger engine from the Pennsylvania Railroad. The train had a Model A engine and a Model T rear end, with a tender and two cars. Unfortunately only the ticket booth and tracks for the train are shown, with Jerry Shaffer and Jean Faller.

LAKE ARIEL PARK OFFICE, 1950. Standing in front of the park office are Mary Oberly Ramble (1911–2006), on the left, and Belle Samson Lesoine (1897–1956). A few years after the park closed, the office was moved across Lake Ariel on the ice and became a cottage at the far end of the lake. The building is today owned by Harold and Carol Whymeyer.

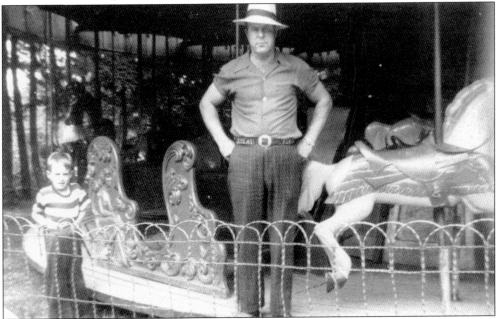

LAST OF LAKE ARIEL PARK'S CAROUSELS. This was the last carousel in Lake Ariel Park. It was bought in 1927 from the Spillman Engineering Company, manufacturers of carousels and other amusement devices. Used until the end of the park, it was then sold to Skyline Park, Tioga Center, Owego, New York. The young boy is Elwin Grover Conklin III (1943–2006), and the ride's operator is Kenneth Hawk (1912–1999). This photograph was taken in 1950.

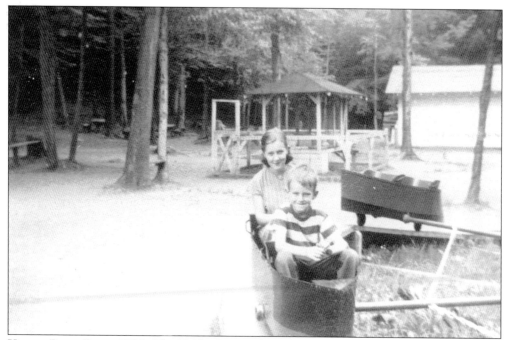

KIDDIE BOAT RIDE, 1950. The Kiddie Boat Ride is shown with Beryl Hawk Swingle (1937–) and Elwin Grover Conklin III. In the background is a springhouse and a refreshment stand with the window openings closed.

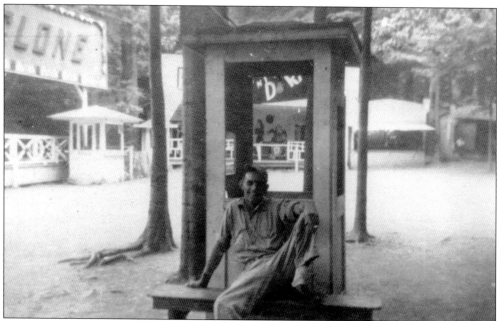

CARL "BOZO" SAAR AT TICKET BOOTH, 1950. In the background are, from left to right, the Cyclone roller coaster and its ticket booth; Fun in the Dark (behind Saar); a souvenir stand, run by Charles Spathelf; and a concession stand. Carl "Bozo" Saar ran the Cyclone.

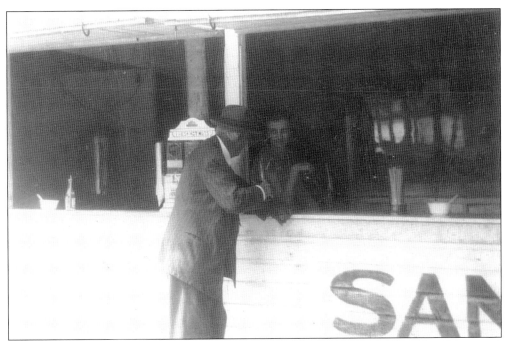

SANDWICH STAND, 1950. "Pop" Hollander chats with Mary Oberly Ramble. Other park employees were Tom Palmer, Ted Franc, Art Lombardi, Eddie Lombardi, Alfred Lombardi, Carl Jones, George Jones, Bob Jones, Harry Gordon, Guy Gibbs, Charlie Bortree, Oscar Bortree, Mildred Lesher, Percy Lesher, Harry Ward, Elaine Franc, Emil Brown, Kathleen Spathelf, Margaret Spathelf, and many, many more.

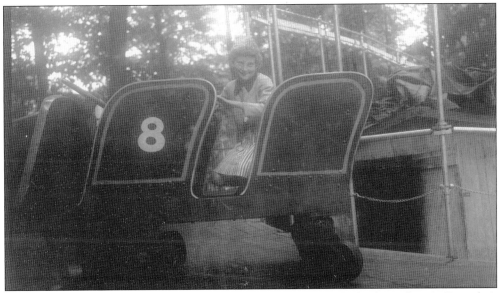

THE HEY-DAY CAR NO. 8, 1951. Sharon (Camin) Birmelin (1944–), Fredric A. Birmelin's wife, is shown at age seven, riding on car #8 of the Hey-Day. Note the open door for storage and maintenance under the ride on the right.

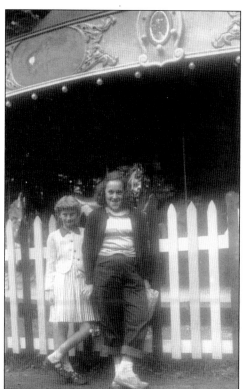

LAKE ARIEL PARK CAROUSEL, 1951. Sharon (Camin) Birmelin (left) is waiting in line with an unidentified girl for a spin on the carousel. Note the colored lights, ornamental mirror, and painted panels on the rounding board.

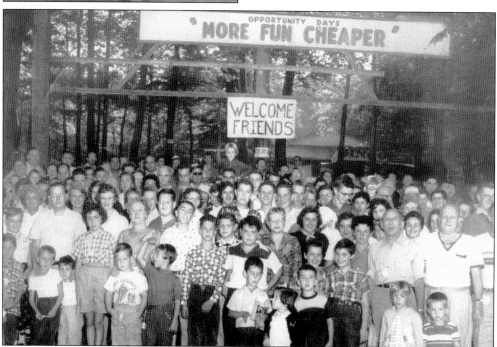

COTTAGERS ASSOCIATION PICNIC IN THE PARK, 1954. When this photograph was taken, F. Burton Derby had just sold the park to A. J. Schrader. No one knew then that the park had only two summers left.

Summer 1956

LITHUANIAN DAY
Sunday, July 22, 1956
LAKE ARIEL
Sponsored by
TAURAS CLUB

NO 1433

1st. PRIZE—6x9 BRAIDED RUG—Cooper Rug Co.
2nd. PRIZE—COFFEE GRINDER—John Luke
3rd. PRIZE—SPINNING OUTFIT—Bill's Sporting Goods
4th. PRIZE—G. E. IRON—Putirskas Jewelry
5th. PRIZE—CASE OF WINE—John Stirna
6th. PRIZE—30 QTS. OF MILK—Adam Martin
7th. PRIZE—ONE HAM—Silver Lake Packing Co.
8th. PRIZE—ONE HAM—Tony Zvirblis
9th. PRIZE—2 CASES OF BEER—Walter Pestinikas

Tickets - 10c 3 for - 25c $1.00 book

LITHUANIAN DAY TICKET, 1956. Nationality days were big at Lake Ariel Park, and bus after bus would bring the people in. One wonders if, in 1956, the ticket holders were more excited over the first or ninth prize.

MONTHLY PASS
issued to

FOR ENTRANCE ONLY TO LAKE ARIEL BEACH
(Does Not Include Locker)

This pass not transferable
and will be forfeited if presented by any except holder whose name appears above.

NOT TRANSFERABLE. MUST BE SHOWN AT BEACH ON DEMAND.

Price —— $1.50 NO 432

MONTHLY PASS TO LAKE ARIEL BEACH. Long after the park closed, the public beach at the north end of the lake kept going, as shown by this pass. Under the blacked-out portion of the image is the date, 1959. The beach remained open until about 1970.

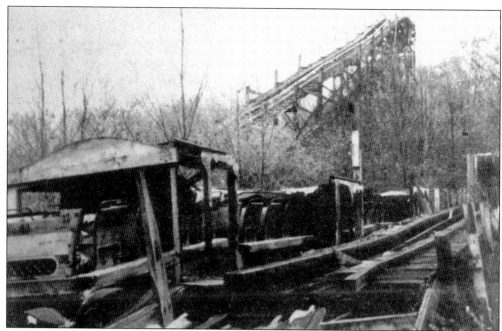

REMAINS OF THE ROLLER COASTER, 1967. When Lake Ariel Park was operating, this roller coaster was its most popular attraction. In 1967, although in hazardous condition, it still stood, more than a decade after the park closed. The coaster is gone today, reclaimed by Mother Nature. In 2004, two of the cars were removed from the park. Salvaged parts from the two cars were incorporated into one new renovated car, as a tribute to the ride.

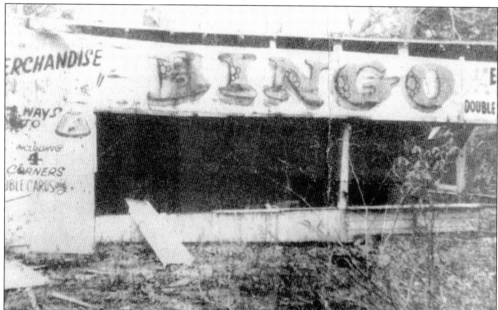

WRECKAGE OF BINGO STAND, 1967. Once upon a time, this Lake Ariel Park stand was crowded with bingo players. In this photograph, taken more than a decade after the park closed, the roof has collapsed and the underbrush and weeds have invaded the premises. No one has shouted bingo for many years. The building is gone as of 2006.

Five

BUSINESS VENTURES

The earliest industries in Lake Township were sawmills. The first sawmill was built around 1816 by Asa Jones and Amos Polley on Five Mile Creek, the outlet of what was then Jones Lake. Shortly after the lumbermen were established, the Gravity Railroad was built. Merchants of all types followed. Later the ice business came with the steam railroad. The ice went out of the area all winter, and the tourists came in for the summer. Stables, hotels, and boardinghouses were also built.

In 1910, the First National Bank of Lake Ariel was born. Over the years, the bank has changed its name twice and its location once. The bank is Lake Ariel's oldest continuous business.

The second-oldest business in Lake Ariel can be tied to the more affluent summer residents. The cottagers came to the lake in their chauffeur-driven automobiles. When one needed automobile repairs, one did not take it to the local blacksmith; one went to the Wayne Garage (now Wayne Body Shop).

The third-oldest business started as a livery and sale stable. By 1917, it was converted into the Farmers Supply Company operated by Thomas Gillette and G. F. Philips. Gillette died in 1922, and the store was purchased by A. M. Spettigue and E. J. Davis. Davis bought out Spettigue in 1928. The business, known as Lake Ariel Hardware, was turned over to Davis's son in 1970.

The fourth-oldest business, Howe Oil Company, opened in 1919 and was owned and operated by John T. Howe. Coal pockets, a gas station, and a fuel oil division were later added. The business still operates on its original site.

The fifth-oldest business in Lake Ariel is the James H. Wilson Funeral Home, founded in 1949. When Wilson and his only son, Tom, died within five weeks of each other, Milt James bought the business from their estates.

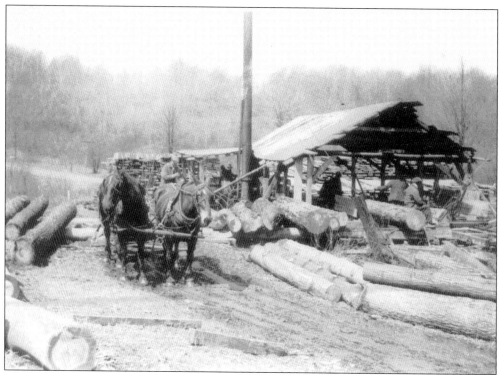

RAMBLE SAWMILL. This early steam-powered sawmill belonged to a Ramble. It was located in Avoy, where the maintenance building for the Hideout is located today.

H. A. SWINGLE'S SAWMILL. This sawmill was off Tresslarville Road. The site is across from Derwin and Lois Brown's home and down the hill. An advertisement for Swingle's sawmill in 1923 stated that he sold "mine supplies, building materials, hardwood, dynamite and boat plank."

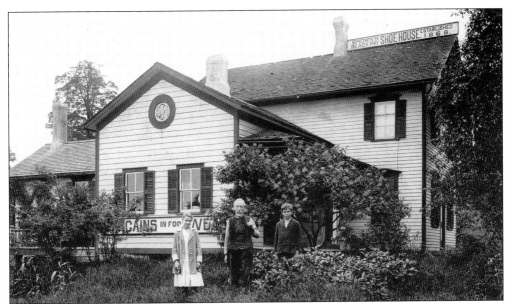

JONATHAN BROWN'S SHOE STORE. This house was built in the late 1840s as a company house for the Gravity Railroad. The building became a shoe shop prior to 1860. In 1868, it became Brown's Ready Pay Shoe House. The 1917 advertising card shown here shows Brown and two children in front of the store. The sign behind the bushes reads, "Bargains in Foot Wear." Today this is the oldest house in Lake Ariel.

MAPLEWOOD CHAIR COMPANY ENVELOPE. Prior to 1878, Maplewood was called Forest Mills. In 1874, the Forest Mills Manufacturing Company was started as a clothespin factory with Washburn and Howell as proprietors. The next year saw a chair factory added to the manufacturing company. The first week of May 1875 saw the factory turn out 15 dozen chairs per day for that week. This envelope was sent to Cross Brothers, which had a store in Sterling.

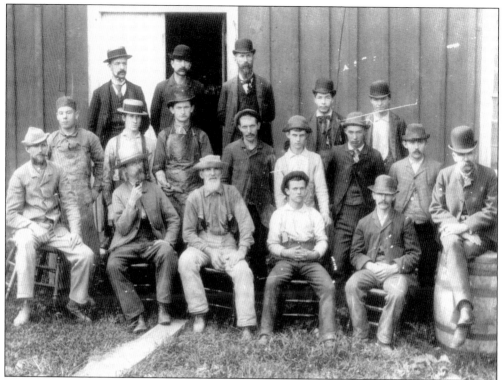

EMPLOYEES OF MAPLEWOOD CHAIR FACTORY. In February 1878, a local newspaper stated, "Schantz and Co. (Jacob Schantz 1846–1896) of Scranton have leased the property known as the Forest Mill Manufacturing Co., in Lake Township. The property includes 1,800 acres of land, factory, mill and tenement houses. The property will here after be used for the manufacture of furniture (chairs)." The men in the *c.* 1889 photograph are sitting on Maplewood chairs.

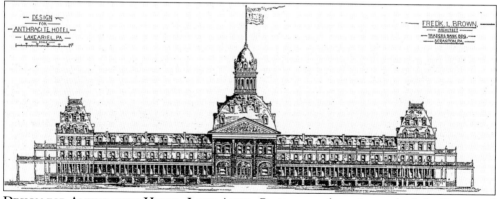

DESIGN FOR ANTHRACITE HOTEL, LAKE ARIEL. Business was booming at the Lake House and the Pines Hotel when this drawing appeared in the *Cricket* of September 1892. This building was to be erected upon the western shore of Lake Ariel. Architect F. L. Brown of Scranton designed the hotel. The front of the proposed hotel was 400 feet in length, with 18 parlors, 305 rooms, 80 baths, bowling alleys, a barbershop, and a convention and musical hall. The grand opening was to be on July 1, 1893.

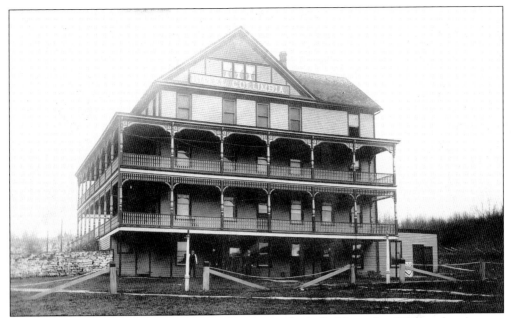

HOTEL COLUMBIA. The Anthracite Hotel was never built. In November 1893, at the entrance to the park, the Hotel Columbia was started. It was built by George F. (1859–?) and Byron A. Simons (1863–1906). The 40-room hotel opened on June 26, 1893. On July 4, 1893, the Hotel Columbia dining room fed 600 people.

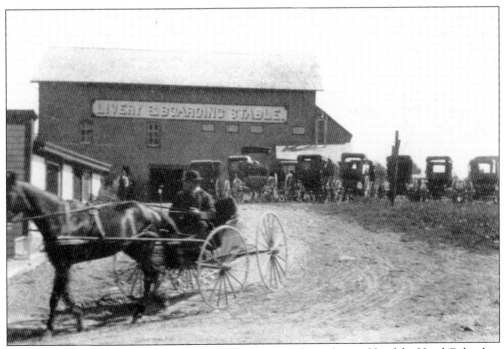

HOTEL COLUMBIA LIVERY, AROUND 1895. The livery and boarding stable of the Hotel Columbia, seen here, was 64 feet long and 25 feet high. It stood behind and to the left of the hotel.

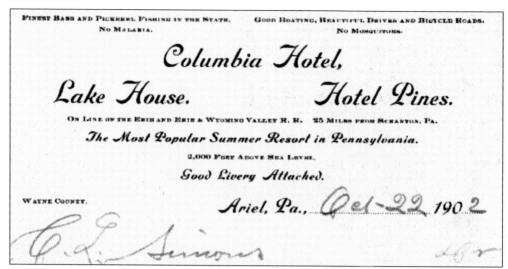

FINEST BASS AND PICKEREL FISHING IN THE STATE. GOOD BOATING, BEAUTIFUL DRIVES AND BICYCLE ROADS.
NO MALARIA. NO MOSQUITOES.

Columbia Hotel,

Lake House. Hotel Pines.

ON LINE OF THE ERIE AND ERIE & WYOMING VALLEY R. R. 25 MILES FROM SCRANTON, PA.

The Most Popular Summer Resort in Pennsylvania.

2,000 FEET ABOVE SEA LEVEL.

Good Livery Attached.

WAYNE COUNTY.

Ariel, Pa., *Oct~22* 190 2

C. L. Simons

LAKE ARIEL IMPROVEMENT ASSOCIATION BILLHEAD, 1902. In 1897, this association, composed of Charles H. Schadt, P. J. Horan and M .J. Healy, purchased Lake Ariel and two hotels. The Hotel Columbia was subsequently bought in 1899 from the Simons brothers. The billhead reads at the top, "Finest Bass and Pickerel in the State. Good Boating, Beautiful Drives and Bicycle Roads. No Malaria. No Mosquitoes."

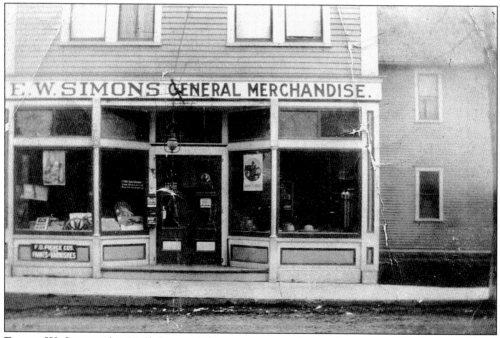

EDGAR W. SIMONS (1857–?) STORE. This store was on the south corner of Maple Avenue and Main Street. Brink and Evans, of Dunmore, built the store in the fall of 1899 for Edgar Simons, who had operated a mercantile store in Lake Ariel from 1889 to 1894 and then worked for his brothers at the Hotel Columbia until it was sold in 1899.

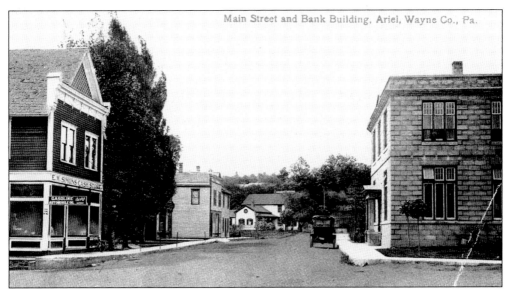

Main Street and Bank Building, Ariel, Wayne Co., Pa.

MAIN STREET LAKE ARIEL, AROUND 1915. Shown here are, from left to right, Simons' Cash Store, J. W. Andrews' General Store, J. A. Bortree's General Store, Jonathan Brown's Shoe Store and house, and Lake Ariel Bank, which is on the right side of Main Street. Simons's store was owned and operated by Joe and Gladys Collins from the 1950s through the 1970s. The building burned on October 13, 1983. Andrews' General Store, which is mostly obscured by trees, also housed the post office.

CHARLES H. SCHADT (1867–1908). Charles H. Schadt Sr. started an ice business in South Scranton. He operated it successfully until his death in 1883, when the management of Consumers' Ice and Coal Company fell to his son. Charles was then just over 16 years old. The business was expanding, and in a short period of time, more ice was needed. Wayne County, and particularly Lake Ariel, offered attractive advantages in the form of its many spring-fed lakes.

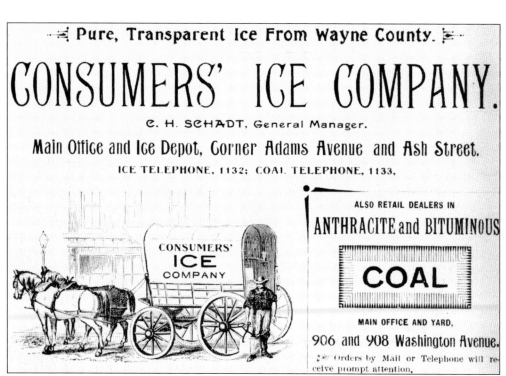

ADVERTISEMENT FOR CONSUMERS' ICE COMPANY, 1894. This advertisement appeared in the book *The City of Scranton and Vicinity and Their Resources,* compiled and managed by H. J. Sutherland and published by the Scranton Tribune Publishing Company in Scranton in 1894. Note the advertisement states, "Pure, Transparent Ice From Wayne County."

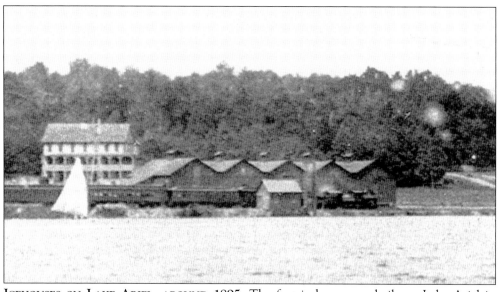

ICEHOUSES ON LAKE ARIEL, AROUND 1895. The first icehouse was built on Lake Ariel in October 1887 and was 100 feet by 60 feet. In less than a month, additions were added, making five icehouses in all. On the left is the Hotel Columbia.

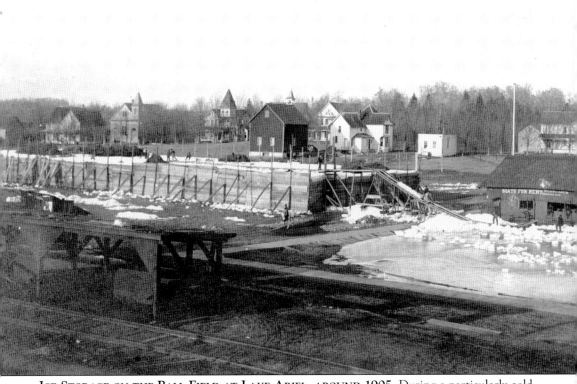

ICE STORAGE ON THE BALL FIELD AT LAKE ARIEL, AROUND 1905. During a particularly cold season, the icehouses would fill up fast, and extra ice storage was placed on the baseball field. As the blocks rose higher, sawdust was spread between them to keep them from freezing together. Temporary walls of planks were built. This ice had to be shipped out first, because the top layer was exposed. In the background is Maple Avenue.

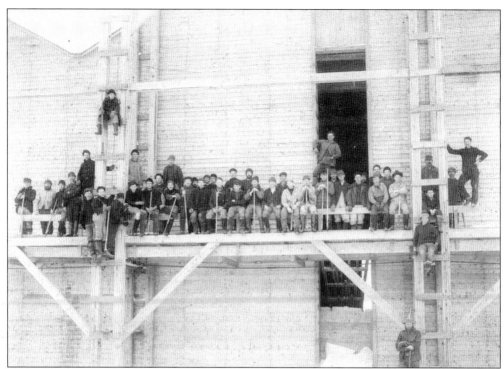

CLOSE-UP OF ICEHOUSES. In 1894, the annual business of the Consumers' Ice and Coal Company was approximately $150,000. At first, the ice blocks were hoisted by horsepower and then later by steam power up to the level that the workers are on. The ice blocks were then dragged with the hooks (seen in the men's hands) to the house and dropped into chutes (opening on right).

WEST SHORE, EARLY 1950s. In the foreground on the right is the remnants of the rails that ran to the icehouses. In 1889, the Knickerbocker Ice Company of New York contracted with Charles H. Schadt for 25,000 tons of ice. Schadt shipped 25 railcar loads a day until the order was filled. This rail spur was the beginning point of the ice shipments.

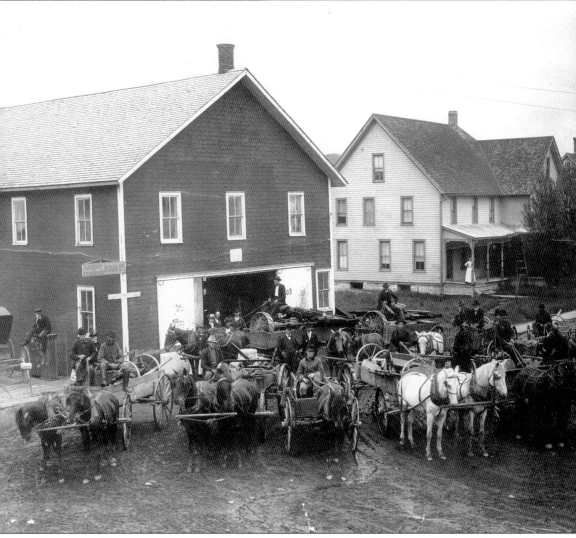

CORNER OF MAIN AND MAPLE AVENUE, AROUND 1900. In 1899, George Kellam's livery and exchange stable was built. A newspaper of the day stated, "The town hall, on the second floor, will be used for political meetings, temperance lectures, negro minstrel troupes and for tripping the light fantastic toe; and we also understand that it is to be the headquarters for the Jones Lake Drum Corps." The itinerant wheat thrashers are shown in front of the building. The Maple Avenue House is to the right.

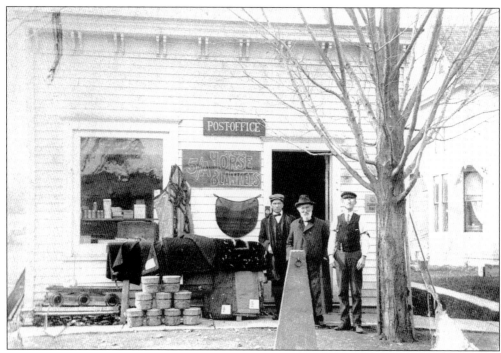

ALVA S. KEYES'S STORE AND POST OFFICE. Alva S. Keyes's store, just up from the lake, on Maple Avenue was the post office from 1900 to 1915 and from 1922 to 1929. Originally established as Ariel in 1851, the post office name was changed to Lake Ariel on November 15, 1927, while it was housed in this building.

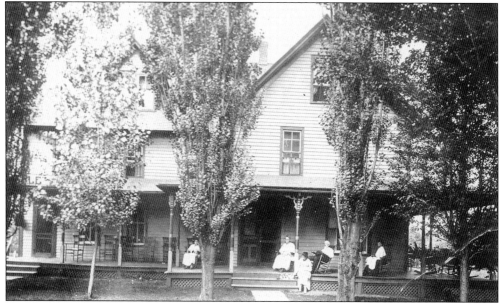

MAPLE AVENUE HOUSE. This boardinghouse was built by George Kellam, next to his livery and exchange stable. It was being managed by Fred Edwards and his brother-in-law Charles Bonham. In 1906, these men bought it and later sold it to Phineas Taylor Howe and Emma Jane (Sinquet) Howe.

Phineas Taylor Howe (1847–1919) and Emma Jane (Sinquet) Howe (1862–1949). When Phineas Taylor Howe died in 1919, his widow, Emma, continued to operate the Maple Avenue House. On December 8, 1945, at 5:15 a.m., flames were discovered coming from the summer kitchen, attached to the hotel. The flames spread through the building, and Lyle Swingle, an occupant, barely made it out. The fire destroyed the boardinghouse and the Union Church next door. Lake Ariel did not have a fire company at the time of the fire.

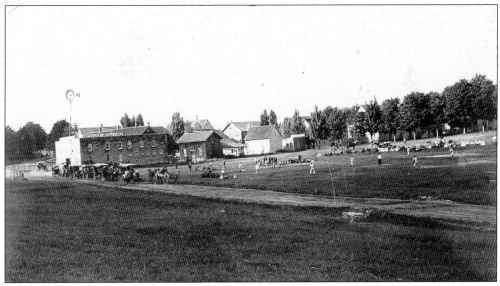

Curtis Livery and Sale Stable and Ball Field. In 1908, W. N. Curtis leased the land in the left of this photograph on both sides of what now is State Route 191 and built his livery and sale stable. Curtis bought and sold western horses. The horses were brought to Lake Ariel by rail and kept on the lot. The corrals were where Howe Convenient is now located. In 1912, Curtis bought the land and then sold it in 1913, to Thomas Gillette and G. W. Phillips.

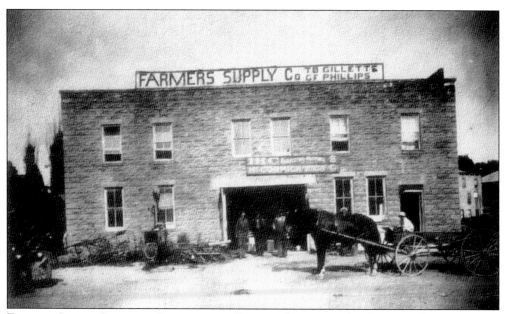

FARMERS SUPPLY COMPANY, GILLETTE AND PHILLIPS (1913–1922). Thomas Gillette and G. W. Phillips dealt in horses. Gillette's son, Frank, was killed by one of the wild horses. The livery gradually became the Farmers Supply Company, selling hardware. After Gillette's death in 1922, the store was sold to O. M. Spettigue and E. J. Davis. Davis lived with his family on the second floor. On December 17, 1927, the building caught fire and was destroyed. The store was rebuilt and is operated by one of E. J. Davis's sons, Arthur Davis.

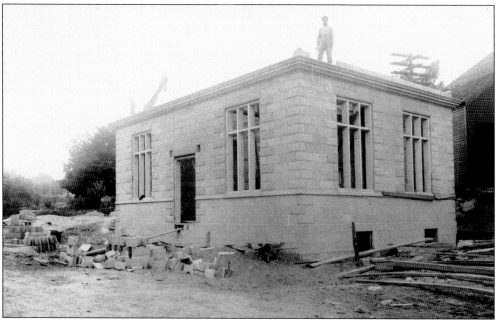

FIRST NATIONAL BANK OF LAKE ARIEL, 1910. On June 4, 1910, the bank's building committee reported "that the building be made out of concrete blocks, one story. " This photograph shows the original one-story bank nearing completion. Elmer Chapman manufactured the concrete blocks, and Harry and Elmer Pugh laid them.

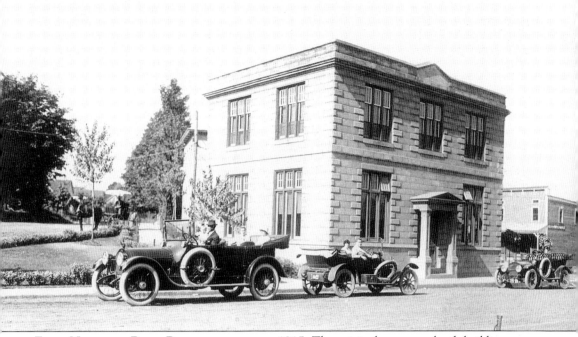

First National Bank Building, around 1915. The original one-story bank building was constructed in 1910 by Elmer Chapman. In 1911, a second floor was added to the building. This view appeared on a bank calendar. The bank used this building from 1910 until 1971. Today the building contains apartments. The store on the right of the picture was torn down for parking.

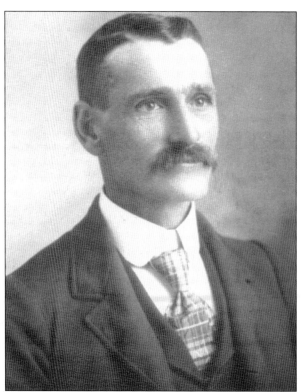

CHARLES SHAFFER (1860–1933). Charles Shaffer, son of Sylvester Shaffer (1826–1903) and Hannah (Swingle) Shaffer (1832–1911), was married to Almina Swingle (1857–1931). He was one of the founders of the First National Bank of Lake Ariel and served as its first president from 1910 until his death in 1933.

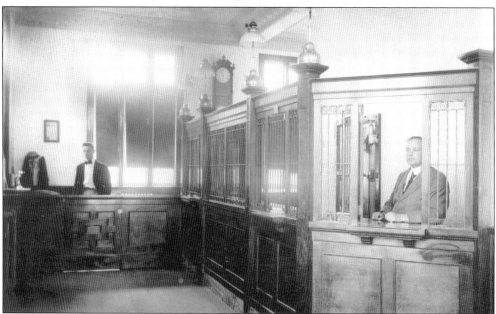

INTERIOR OF FIRST NATIONAL BANK OF LAKE ARIEL. The man behind the counter on the left is Merton J. Emery, board member and cashier. Emery rented the second floor of the bank for $15 per month. The man on the right is Roy Norman Howe (1885–1965), who became cashier in 1916. Note the tellers' cages. In 1913, the bank president was "authorized to purchase glass to place before the grill in the bank."

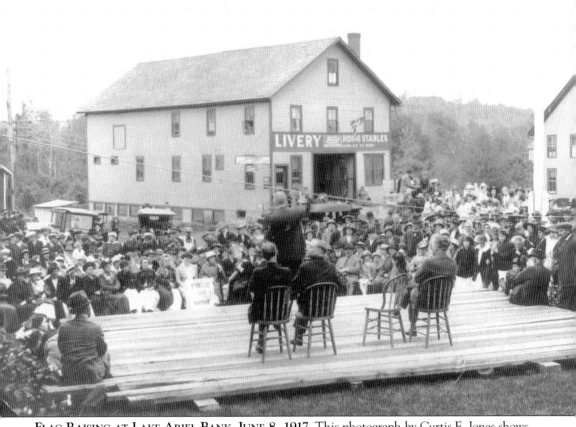

FLAG RAISING AT LAKE ARIEL BANK, JUNE 8, 1917. This photograph by Curtis E. Jones shows the flagpole (on right) contributed by Charles Shaffer. The 77.5-foot tree was cut at Mount Cobb in Lackawanna County. The bank donated the flag, which was 10 feet by 15 feet. Rev. R. L. Cooper of the Methodist church was chairman, the invocation was given by Rev. F. B. Helsman of the Jonestown Presbyterian Church (on Golf Park Drive), and the addresses were made by M. J. Hanlan and C. P. Searle of Honesdale. In the center is Kellam's Livery, which is still standing today as the Liberty Restaurant.

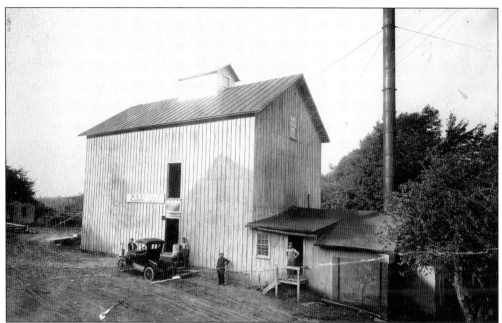

H. A. SWINGLE'S FEED MILL. This feed mill was built by Silas Bortree (1852–1923) and operated as S. C. Bortree and Sons (sons were Howell and Floyd of Lake Ariel Park fame). The mill was sold to Howard Asher Swingle (standing in door at far right). In 1922, Grove and Lyle Swingle bought the business from their father, and it became Swingle Brothers Feed and Grain. Howard kept his lumber interests and later built H. A. Swingle Lumber and Hardware Company next door to the feed mill. Both buildings still stand on Tresslarville Road.

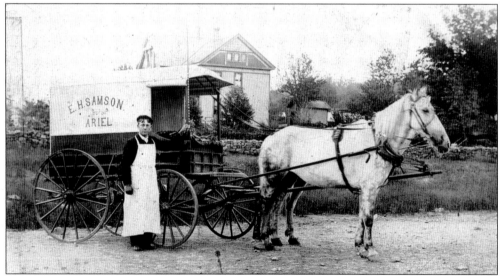

E. H. SAMSON MEAT WAGON. In June 1895, Eugene H. Samson (1873–1948) opened a meat market in the east basement of Susan Schenck Sandercock's store. Sandercock's home is in the background of this photograph. The background site is where the present-day St. Thomas More Parish Center stands. Later Sandercock's store was rented to Eugene's brother Joseph and one of his brothers-in-law, Judson Cook. On October 25, 1912, Samson and Cook's was destroyed by fire. Pozza's Floral stands on the site today.

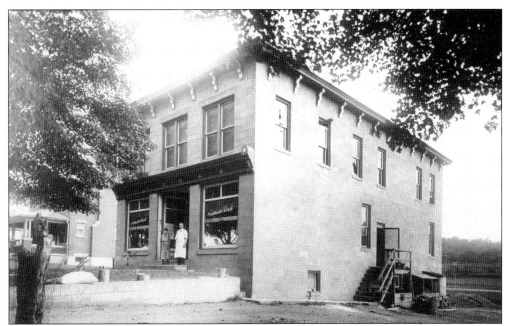

SAMSON AND COOK'S NEW STORE, 1913. Joseph Samson (1875–1935) and Judson Cook (1876–1971) bought a lot 60 feet by 150 feet on Maple Avenue after their wood frame store burned. The old store was opposite the Sandercock house and the school. The new concrete block building was 32 feet by 60 feet and was built in 1913.

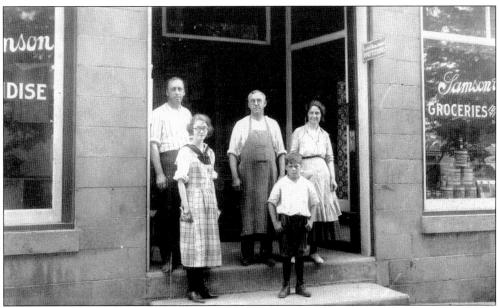

SAMSON AND SAMSON MERCANTILE, AROUND 1920. Cook left the partnership and built a bakery and soda fountain next door to the new building. Joseph and his brother Harry formed a new partnership. Seen in the photograph are, from left to right, (front row) Lou Kizer Samson (1878–1967), Harry's wife; and Emery Gerald Samson (1911–1957), Harry's son; (second row) Harry Samson (1878–1939), the new partner; Joseph Samson (1875–1935); and Mary Kizer Samson (1878–1957), Joseph's wife.

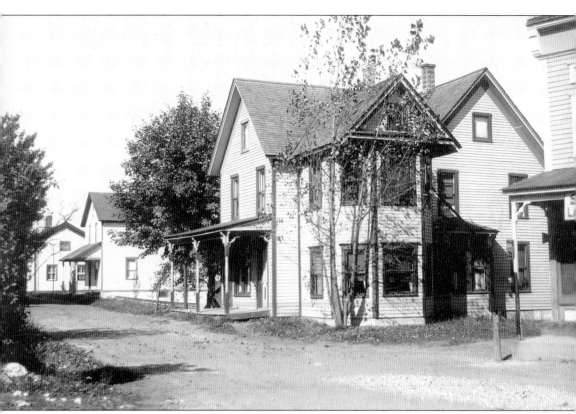

ROBERTS/RAMBLE HOME AND LONSTEIN'S STORE. The store on the right was Samuel Lonstein's and was built around 1907. A 1917 advertisement stated that he sold "Dry Goods, Notions, Boots, Shoes and Furnishings for Ladies and Gentlemen—Fine Line of Groceries." By the early 1920s, the store was sold to J. C. Pennell. It was torn down in 1977. The old Roberts/Ramble home (center) is Kay's Italian Restaurant today.

SAMUEL LONSTIEN
LAKE ARIEL, PA.

Ladies' and Gents' Clothing
SHOES, HATS & CAPS
FULL LINE OF GROCERIES.

PAPER BAG, AROUND 1910. This advertising bag is from Lonstein's store on Maple Avenue. Note the last name is misspelled. The site is now the parking lot for Kay's Italian Restaurant.

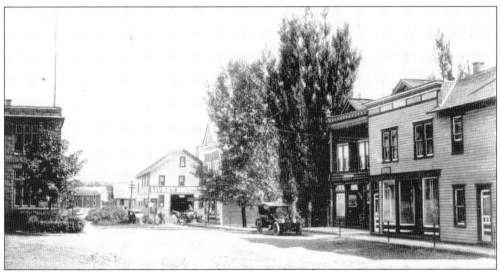

MAIN STREET LOOKING EAST, AROUND 1918. On the left is Lake Ariel Bank (note the 77.5-foot flagpole), Kellam's Livery is in the center, the E. W. Simons store is behind the trees, J. W. Andrews' General Store is to the right of the trees, and J. A. Bortree's General Store is on the extreme right. Bortree's store has been torn down to make a parking lot.

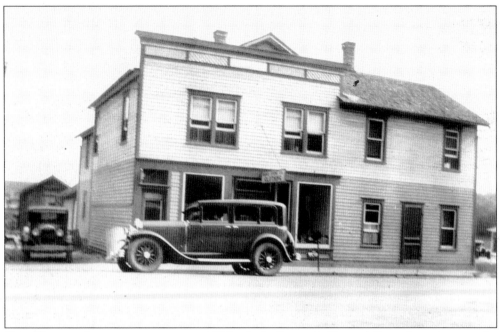

THE WAINCO STORE, AROUND THE 1930S. J. A. Bortree's General Store later became the Wainco Store Company. The store carried clothing and footwear, with Otis Smith as proprietor. The door on the right was O. M. Hoover's Barber Shop. A haircut was 35¢, children 25¢ (except Saturday), and a shave 20¢, and there were "Clean Towels for Every Customer."

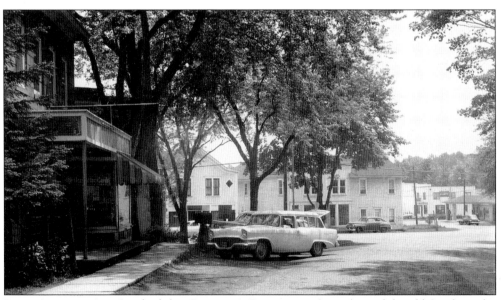

LAKE ARIEL, 1950S. On the left is Patterson's Department Store (site of the old Sandercock's store, then Samson's store, and today Pozza's Floral). In the background and next on the right is Robert Jones' Inn. The Wainco Store is on the corner, and farther in the background is Gershey's Electric, now a parking lot.

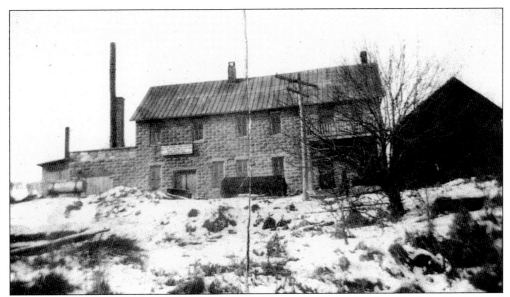

LAKE ARIEL CHEESE MANUFACTORY. The first creamery at Lake Ariel was built by H. B. Neeff in 1890, between the north end of Maple Avenue and Gravity Road. It was called the Lakeside Creamery. In 1896, Neeff built a new creamery across Gravity Road. By 1905, Neeff's creamery was listed as idle. All or part of that building make up the Lake Ariel Cheese Manufactory, started by V. D. Santoro and Emilio Lombardi in 1908.

V. D. SANTORO	Scranton Phone: Old 5793-R Lake Ariel Phone: Old 32-4	E. LOMBARDI

Scranton, Pa.,...................................191

M...

To V. D. SANTORO & LOMBARDI, Dr.

LAKE ARIEL CHEESE MANUFACTORY

CACIOCAVALLO, SCAMORZE, BUTIRRO
E RICOTTE FRESCHE E SECCHE ALL'USO D'ITALIA

Fresh Butter and Cream. Main Office; 147 SOUTH SEVENTH AVE. All Claims must be made within 5 days after receipt of goods.

BILLHEAD OF SANTORO AND LOMBARDI. V. D. Santoro and Emilio Lombardi ran the Lake Ariel Cheese Manufactory, with the main office at 147 South Seventh Avenue in Scranton. About a half-dozen men made cheese such as provolone, ricotta, and mozzarella.

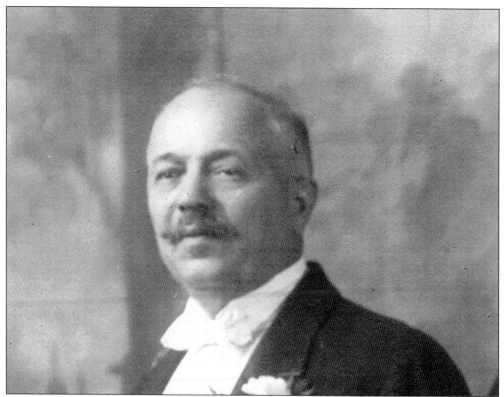

V. D. Santoro. V. D. Santoro was Emilio Lombardi's partner. On the first week of March every year, the local farmers would meet with these men and agree on the price of milk during the year. In 1910, the price ranged between 2.25¢ and 4¢ per quart.

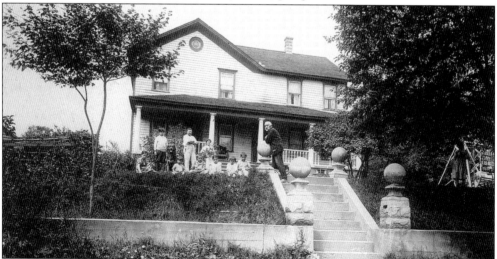

Emilio Lombardi Home. A July 1912 newspaper stated, "E. Lombardi has greatly improved his premises by filling in and terracing the front yard. Cement steps handsomely finished adorn the front entrance." Lombardi and his second wife, Matilda, pose with his nine children and a dog. The children's names were Vincent (by first wife), Bob, Lucy, Art, Delia, Eddie, Armand, Alfred, and Oswald. This house still stands on Gravity Road.

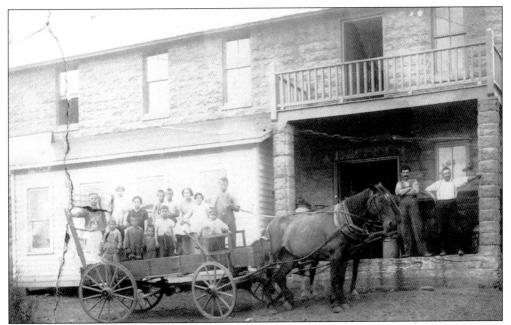

LOMBARDI CHEESE FACTORY, 1922. Santoro left the factory, and Lombardi ran it until 1932. Shown here in the wagon are the 14 children and stepchildren of Emilio Lombardi. His wife Matilda died in 1918, and Emilio married for a third time, to Rose Matteo. Rose's previous husband had died, leaving her with four children, Minnie, Tony, Phil, and Lena. Rose and Emilio had one child, Emil.

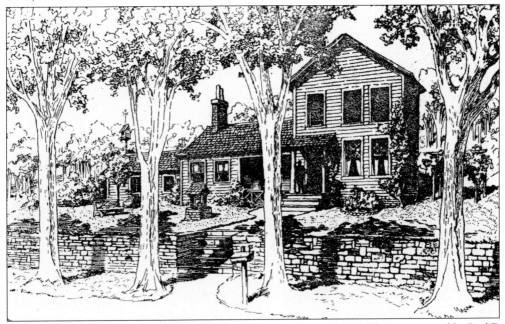

FEATHER CREST FARM . This farm is on White Road (an area called Pink). It was owned by Paul F. Johanning (1872–1929). He came from New York to the country in 1913 for health purposes and engaged in the breeding and selling of single-comb, white leghorn chickens. Johanning was also a writer and composer of music, with several first-class publishing houses handling his productions.

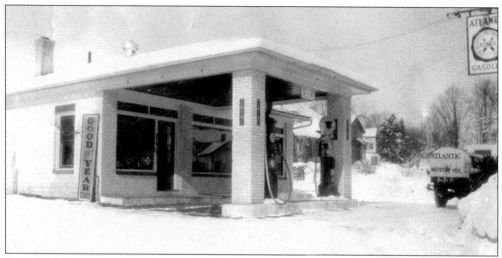

JOHN T. HOWE'S GAS STATION. John T. Howe (1897–1992) started in business in 1919. The business grew and, in 1924, coal pockets were added. The station in the picture was built in 1928. One of John's sons, Bruce D. Howe (born 1931), took over the business in 1966.

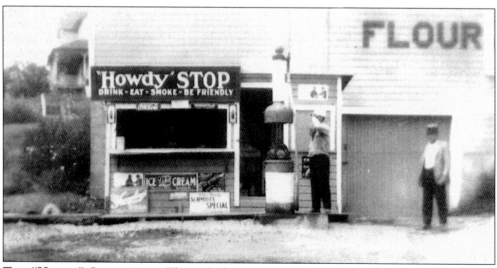

THE "HOWDY" STOP, 1930s. This refreshment stand was added to the front of Ariel Feed and Grain Company and run by James Sandercock Moffat (1911–1958). The stand's motto was "Drink – Eat – Smoke – Be Friendly." To the left, just out of the photograph, was the Lake Ariel train station.

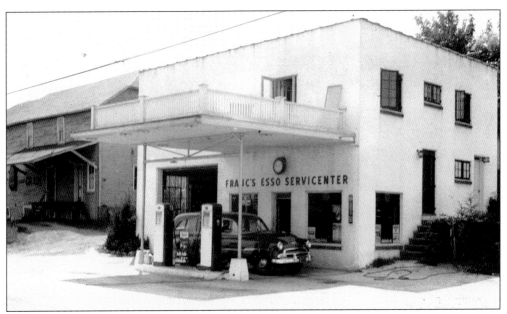

FRANC'S ESSO SERVICENTER, 1950S. Sherwood Franc (1908–?) built this Esso gas station in 1946, next to what is now the Lake Ariel Fire Company building. It continues as Enslin's car repair shop to this day.

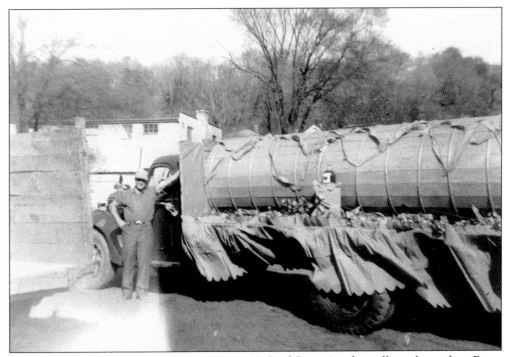

EMIL BROWN'S CIDER MILL AND TRUCK, 1955. Emil Brown's cider mill was located on Franc Road, near what is now the ski slope in the Hideout. Brown's truck is decorated to be in the Lake Ariel fireman's parade. Kenneth Hawk is the driver.

CURTIS JONES PHOTOGRAPHY GALLERY. This building was built in 1898. The upper floor was the Curtis Jones Photograph Gallery and a salesroom for picture frames. The first floor was Frederic L. Keene's printing press and bicycle repair shop. The building was on Main Street, and today is the site of Chapman's Barber Shop.

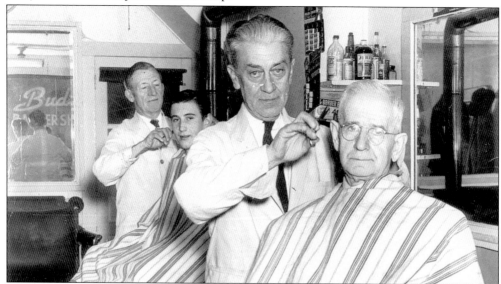

INTERIOR OF BARBERSHOP 1950S. This was the same building that Curtis E. Jones built as his photography shop. Barber Bud McCoy is shown in the foreground, and "Hick" Polley is in the background, cutting Jim Kobesky's hair.

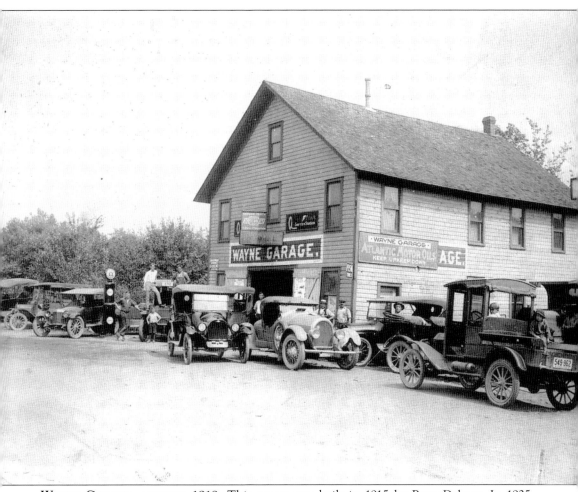

WAYNE GARAGE, AROUND 1918. This garage was built in 1915 by Peter Delorey. In 1925, Delorey sold the building to William J. Axworthy. Catherine D. Axworthy, widow of William, sold the building to Raymond Zeiler in 1958. Zeiler changed the business from mechanical repairs to bodywork. In 2000, the business passed to Zeiler's one son, Dan, who operates it today. The child in the back of the pickup on the right is believed to be Axworthy's daughter. Behind her, in the shadows, is her father.

WAYNE THEATER. On July 2, 1927, the Wayne Theater opened next to the Wayne Garage. The theater ran a seven-reel feature with a newsreel and a comedy reel. It stopped showing movies in the early 1940s. Fred and Lynne Birmelin bought the building in 1957 and ran the restaurant part of the business until they sold it to Frank and Adele Flynn. Flynn next sold it to Robert Birmelin (the Birmelins' son). After a fire in the late 1970s, the old theater building was torn down.

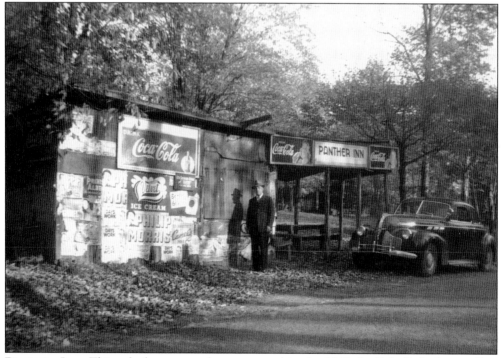

PANTHER INN. This refreshment stand was operated in the 1940s by Dale E. Lesher on East Shore Drive, near the intersection with Island View Drive.

Six

COMMUNITY LIFE

Lake Ariel has always had an interest in education. The first school was held in 1823 in the barn of Amasa Jones, son of Asa. A log school was built the following year by Amos Polley and Lawrence Tisdel. It was replaced by the octagon stone school that was erected in 1851. Up to 1875, the school pulled double duty by also being the home of the Jones Lake Baptist Church (founded in 1854).

In 1852, Rev. G. W. Leach, a Methodist minister, had opened the first monthly church services in Tresslarville. The next year, Rev. C. B. Arnold was preaching at the Turnpike School, near the current-day Lake Township Municipal Building. The next visit by the minister was held at the home of Dwight Mills at Ariel. During a slack time for the men of the Gravity Railroad, a school and a preaching area were built just down the hill. The building was located just behind Jonathan Brown's Shoe Store. This building was torn down in 1897, when the graded school was built. Rockwell Hall stood on the same site for many years afterward. Today it is a parking lot.

A community as prosperous as Ariel was usually had a doctor. A newspaper article from the mid-1800s tells about Dr. William L. Marcy, Ariel's first doctor: "a patient called on Doctor Marcy complaining of indigestion. After giving the patient a little bottle of pills the doctor told him to drink hot water an hour before his breakfast. The following day the patient returned to Doctor Marcy and complained that he simply could not do it. He drank hot water for fifteen minutes and was completely filled up and could drink no more."

The early homes of Ariel were as varied as the people in them. Farm homes of men like Allen Tressler were in close proximity to the mansions of John W. Sandercock and Millionaire's Row on the lake. As one goes through the 1900s, one sees images of the boys coming home from World War I, the Ford Day baseball games, summer and winter activities on the lake, and the increasing business and social activity around the town. The final part of this journey is a stroll down through the cottages and the Young Women's Christian Association (YWCA) camp. This is *Around Lake Ariel.*

1896 * 1897

❖ ✕ ✕ ❖

"Ah me! those joyous days are gone!
I little dreamt till they had flown,
How fleeting were the hours."

Name, *Alma Wells*.

Days Present, Days Absent,

✳✳✳✳✳✳✳✳

SCHOOL No. 17,

LAKE TOWNSHIP, WAYNE CO., PA.

* Pupils *

Stella Bidwell	Alfred Spangenberg
Florence Jones	Eddie Seeley
Oscar Bigast	Nellie Ely
John Seeley	Ester De Proat
Linda Bidwell	Wilmer Brundage
Laura Williams	Ernest Daniels
Geo. Spangenberg	Mabel Wells
Elbert Wells	Arabella Jones
Lottie De Proat	Willie Seeley
Margery Daniels	George Williams
Truman Daniels	Ar.na Kirby
Lloyd Ely	Lewy Curtis
Ellen Curtis	Elsie Wells
Alma Wells	Howard Spangenberg
Floyd Brundage	Willie Harris
Friend Hughey	Ethel Ely
Gartie Spangenberg	Alvin Kirby
Alice May Wells	Jennie Spangenberg

* Directors *

R. P. Jones,	E. H. Samson,	George Simons,
Henry Shaffer,	H. O. Silkman,	George Miller.

D. L. Hower, Co Sup't.

J. V. DE LANEY, Teacher.

H. G. Phillips, Publisher, Williamsport, Pa.

SOUVENIR OF SCHOOL NO. 17, 1896–1897. This card is from the Pink school. Pink was an area that grew up around Plane No. 17 on the Gravity Railroad. The name came from large clusters of wildflowers that were called pinks. The school still stands on the left side of Stock Farm Road, behind Shalom Acres. The school was also home to the Free Methodist Church. Note the names; Florence and Arabella Jones and Elbert and Elsie Wells all became teachers.

GRAVITY DISTRICT SCHOOL. This school in Lake Township, near the top of Gravity Hill, became the first County Standard School in 1917. To encourage single-room schools to hold to high standards, the state had a system by which the district received a pennant of honor if the state requirements were met. Beulah A. Swingle was the honored teacher. The school was turned and made into a residence and still stands today.

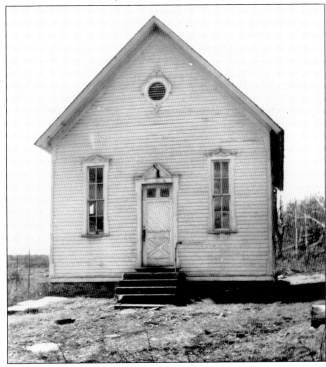

ELM SCHOOL, AROUND THE 1940s. The Elm School was located on Silkman's Road, Lake Township. The school closed in 1936. Friend Black was the last teacher. Calvin Shaffer (1890–1971), son of Charles Shaffer and Almina (Swingle) Shaffer, tore the school down for the lumber.

ONE-ROOM SCHOOL AT ARIEL. This school was located on Gravity Road across from the Lombardi home and cheese factory. Fannie (Vandervoort) Spangenberg (1910–1999) told in later years, "The lower half of the school's windows were painted white to stop the children from watching the men working in the cheese factory and pay attention."

LAKE ARIEL GRADED SCHOOL. In May 1897, the contract for the erection of the graded school building was awarded to Robert Swingle of South Canaan. Swingle subcontracted the masonry work to George Kellam of Lake Ariel. This school opened in September 1897. The building on the left is the Sandercock/Howe house, now the site of the St. Thomas More Parish Center.

LABORATORY SCENE AT LAKE VOCATIONAL SCHOOL, 1916. The high school became a vocational school in 1916. Doing an experiment at the table in front are Grove Swingle (left) and Vincent Lombardi. In the back are, from left to right, Dewitt Quintin, unidentified, Russell Hazlett (behind Vincent), and Jake Curtis.

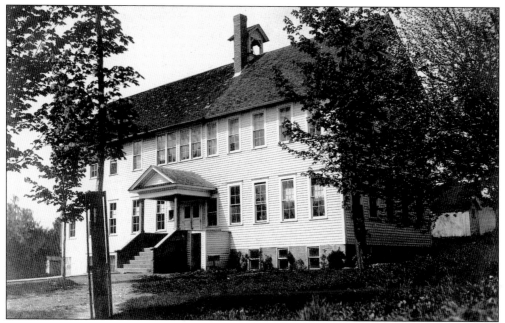

LAKE ARIEL HIGH SCHOOL. In 1900, Lake Township established a high school in the graded school building. The first graduating class, in 1902, consisted of three girls and one boy, namely, Norma Cobb, Elsie Howe, Ethel Headley, and Morton Moore. In 1904, the course was lengthened to three years. The attendance grew rapidly until an addition was added to the school around 1910.

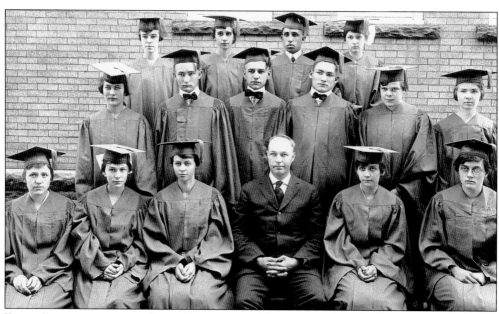

FIRST COMMENCEMENT OF LAKE VOCATIONAL SCHOOL, 1918. Pictured here are, from left to right, (first row) Helen Megargle, Julia Fowler, Vesta Swingle, John D. Storm, Ida Ammerman, and Marjorie Smith; (second row) Ruth Chapman, Howard Chapman, Russell Hazlett, Frederick Polley, Helen Lawrence, and Helen Osborne; (third row) Mildred Bank, Mabel Black, Vincent Lombardi, and Pearl Chapman. Graduation was held at the Methodist church.

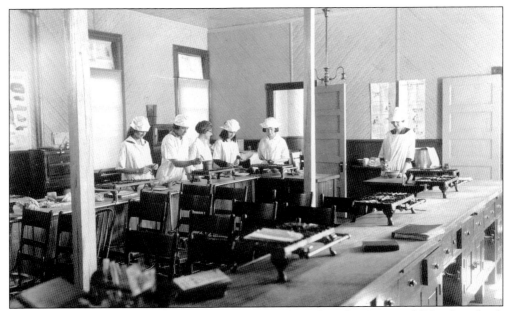

COOKING CLASS AT LAKE VOCATIONAL. A quotation from the Lake Vocational School yearbook of 1923 says that "the Home Making Department has as its aim the training of girls in the many duties as practiced by the wife and mother in the home. She is cook, seamstress, house decorator, manager, financier, counsellor and nurse." In the cooking class from the mid-1920s are, from left to right, Bea Kimble, Hazle Afford, teacher Ruth Riefenberg, Peg Swingle, Gertrude Lesher, and Helen Swingle.

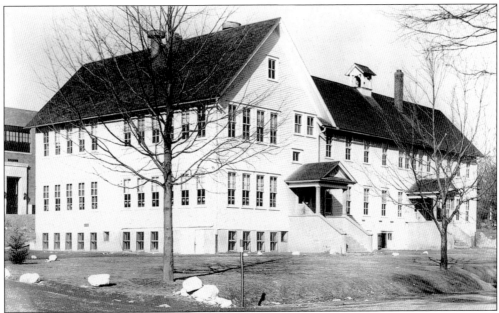

LAKE VOCATIONAL SCHOOL, 1937. In 1924, five classrooms and indoor bathroom facilities were added to the south end of the school. This was the last addition to the old graded/high/vocational school building. Note that the new school can be seen in background on the left. Shortly after this photograph was taken, the old wooden building was torn down.

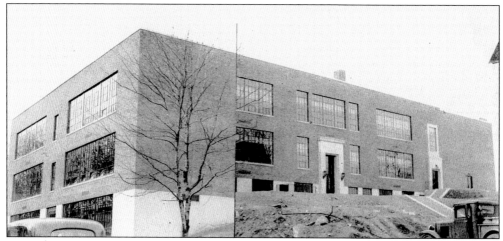

THE NEW LAKE TOWNSHIP CONSOLIDATED SCHOOL, 1937. This building was started in the spring of 1936. It was built of concrete blocks, with brick veneer on the front and sides. The new school cost $100,000 and was built as a WPA project. The school became part of Western Wayne Joint Schools in 1961. This building has been the Lake Elementary Center since the new high school opened in 1973 at Varden, South Canaan Township.

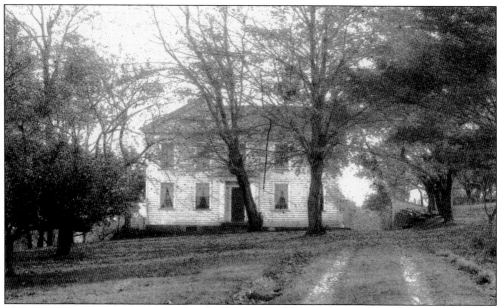

DWIGHT MILLS'S HOME. This house dates to the late 1840s. In 1853, Rev. C. B. Arnold, a Methodist minister, was invited by Dwight Mills to preach at his home, which he did to a crowded house. By the late 1850s, the Methodists were meeting in the school just down the hill. St. Thomas More Church purchased this house in the mid-1940s and made it into a convent for the Bernadine Sisters of St. Francis. The mid-1970s saw the convent renovated into classrooms. In the 1990s, the building was replaced with a new rectory.

THE SECOND UNION CHURCH, AROUND 1905. This close-up of the photograph titled "Ice Storage on the Ball Field" is the only known view of the second Union Church (in center). The first church had been dedicated in 1890 and burned on February 24, 1901. This building was built in 1901 and was destroyed by the same fire that consumed the Maple Avenue House in 1945.

LAKE ARIEL UNITED METHODIST CHURCH, 1950s. On June 1, 1901, the Lake Ariel Improvement Company deeded a lot on Maple Avenue to the Methodists. Two weeks later, ground was broken. The cornerstone was laid on July 11, 1901, by Rev. J. E. Warner. The church was dedicated on November 21, 1901. The church is still going strong.

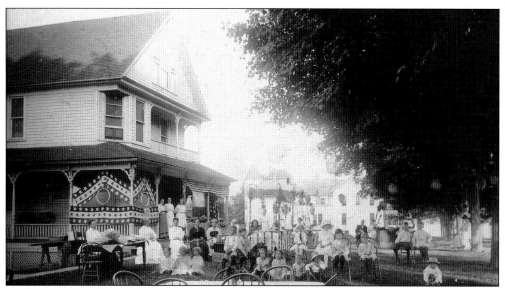

LAKE ARIEL UNITED METHODIST PARSONAGE, AROUND 1908. The occasion is the Fourth of July Sunday school picnic. The parsonage, which was built in 1902, was a gift of Cyrus D. Jones of Scranton. Note the Lake House, which was destroyed by fire on March 3, 1916, in the background.

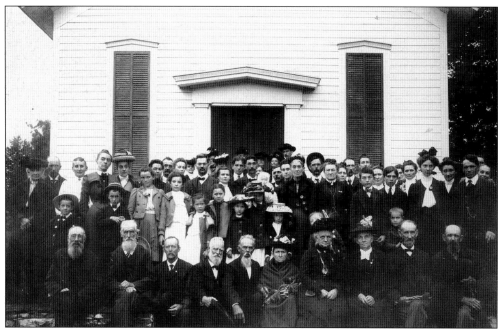

JONES LAKE BAPTIST CHURCH. The 1903 Jones reunion was held at the Jones Lake Baptist Church, shown here. This is the only photograph found of the church in operation. The church was enclosed, covered, and floored by Daniel Brundage in 1875. The building was completed in 1880. This church, which closed its doors on November 11, 1956, is still standing on Golf Park Drive.

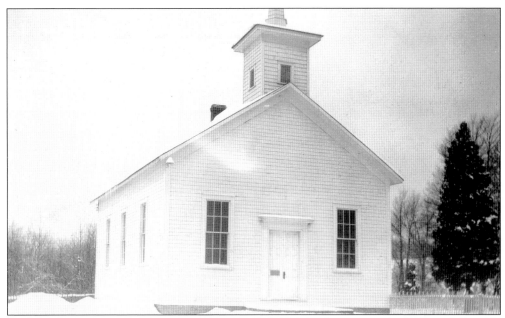

AVOY CHRISTIAN CHURCH, LAKE TOWNSHIP. In 1870, land was given by William J. Ramble as a site for the Avoy Christian Church. The church was dedicated in the summer of 1871. A great improvement was made in 1946, when electricity replaced the kerosene lanterns. In 1951, a pipeless furnace retired the two potbellied stoves that had heated the building. The church still stands and holds services every Sunday morning.

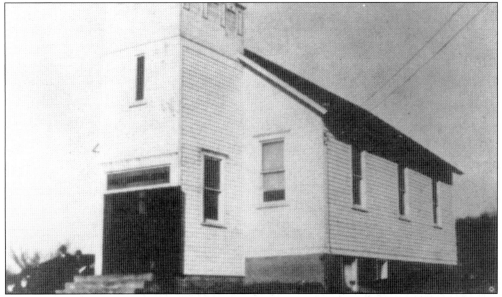

GRAVITY PENTECOSTAL CHURCH, 1927. This church was built on land that was donated by Oscar Schell and was dedicated on December 25, 1921. The church became affiliated with the Assemblies of God in 1925. A Gothic steeple and vestibule were added to the building in 1927. In 1945, the church moved to Hamlin to find more space. The Gravity Pentecostal Church was sold in 1946. The steeple was torn off, and the building was made into a house, which is located halfway up Gravity Hill.

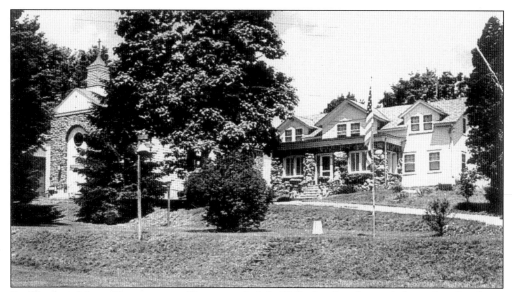

St. Thomas More Church and Rectory. In July 1942, the church was dedicated with solemn mass celebrated by Fr. Joseph Corcoran and assisted by Fr. Francis Toolan and Fr. Edward McGuire. In 1996, the rectory was torn down for church expansion. Under Fr. Edward Scott, a new church was built, and the old church (on left) was renovated into a chapel and office space.

Dr. W. L. Marcy Bottle, around 1875. Dr. William L. Marcy was born in Pittston. He attended Castleton Medical College in Vermont, graduating in 1856. In 1873, Dr. Marcy moved from Hawley to become the first permanent doctor at Ariel. The label on this bottle reads, "Laudanum. W. L. Marcy, M.D., Druggist and Bookseller, Ariel, PA." Laudanum is a tincture of opium.

DR. HARRY B. ELY'S HOUSE, MAPLE AVENUE. Dr. Harry B. Ely graduated from Jefferson Medical College, Philadelphia, in 1886. He built this house on Maple Avenue in 1895. Dr. Harold Cummings White, the next owner of this house, graduated from Long Island College Hospital in 1894, moved to Lake Ariel in 1897, and practiced medicine for 65 years, until his death in 1962. The house was destroyed by fire on February 8, 1977. It belonged to the Fahrenbachs when it burned.

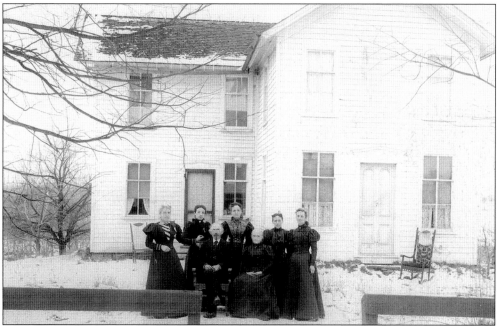

RESIDENCE OF ALLEN TRESSLER. Allen Tressler's family gave Tresslarville its name. Tressler married Mary Hafler, and they had six children: five girls (shown in picture) and one boy. The five girls standing are Emma Brooks, Hattie Jaggers, Alice Bishop, Nettie Shaffer, Della Morgan, and Charles Tressler. The house still stands today on the Easton Turnpike in Tresslarville.

(No Model.)

C. FOWLER.
CLOTHES DRIER.

No. 559,057. Patented Apr. 28, 1896.

Fig. 1.

Fig. 2.

Witnesses Inventor

C. A. Ford Charles Fowler;

By his Attorneys,

PATENT FOR CLOTHES DRIER. Charles Fowler married Georgia Case in 1877 and moved into a house on Tresslarville Road. Fowler worked on the Gravity Railroad and loved to tinker around. This paid off on April 28, 1896, when he was granted a patent from the United States for the clothes drier shown here. The patent was witnessed by Edgar W. Simons (storekeeper in Ariel) and Jonathan Brown (shoemaker in Ariel).

118

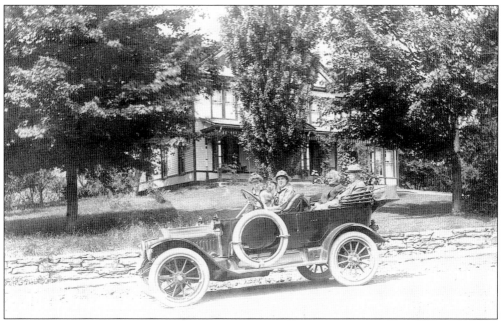

JOHN W. SANDERCOCK'S HOUSE. John W. Sandercock married Susan Greene (Homer Greene's sister). They first lived over John's store. In 1888, Susan's father, Giles, built the large house (later John T. Howe's) in the background for them. Here the Sandercocks are in the back of their White motorcar with, from left to right, an unidentified friend, their granddaughter Barbara Sandercock, and their daughter-in-law Dorothy in the front. The house was razed for St. Thomas More Parish Center.

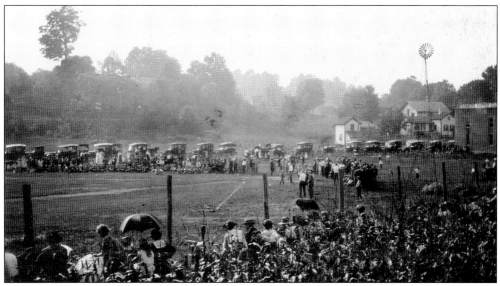

FORD DAY AT LAKE ARIEL. Ford Day was started in 1915, by Floyd E. Bortree. At that time, Bortree was a Ford automobile dealer for Wayne County. Each year, he held a big outing for the owners of Ford cars in his territory. This was done annually for 12 years. In 1917, Bortree started selling Buicks also. In 1927, he sponsored the first annual Buick Day at Lake Ariel Park.

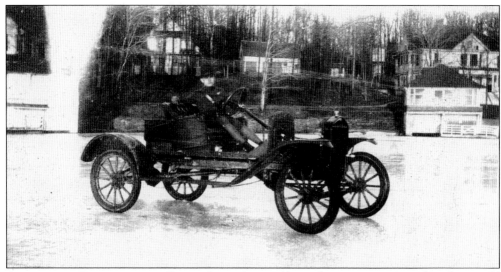

AUTOMOBILE RACING ON THE ICE AT LAKE ARIEL. Shown here is Grove Swingle in his World War I uniform, driving Claire Johnson's stripped-down Ford on a frozen Lake Ariel. This sport continued for many years. In 1968, Stan Myers of Doylestown lost his Saab through the ice during a cars-on-ice rally. Three weeks later, the car was pulled up from under 20 feet of water and 17 inches of ice.

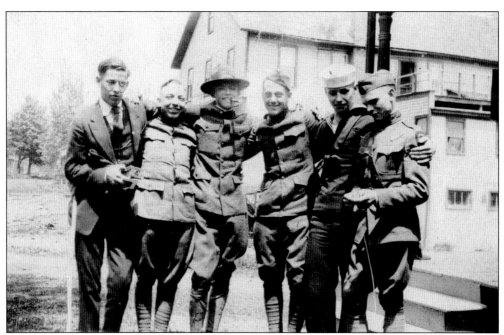

THE BOYS OF WORLD WAR I. Lake Ariel welcomes back the boys of World War I. Shown in this photograph are, from left to right, John T. Howe, Lyle Swingle (armored division), Grove Swingle (regular army), Otis Smoth, Linton Hazlett (navy), and Claire Johnson (pilot).

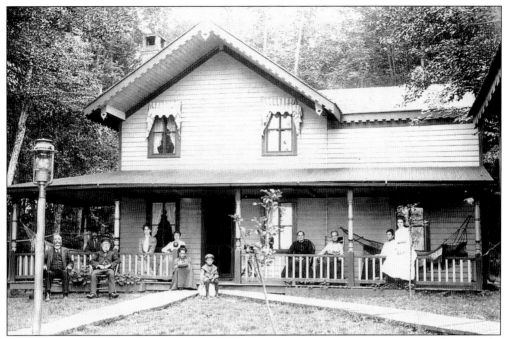

OLDEST COTTAGE ON LAKE ARIEL. This cottage was built in 1861. Originally consisting of just one room (downstairs left), it was the sawmill office of Joel Jones. The building was added onto and became a cottage in the 1880s. The cottage is now owned by Janet F. Dickinson and has been in her family since 1902.

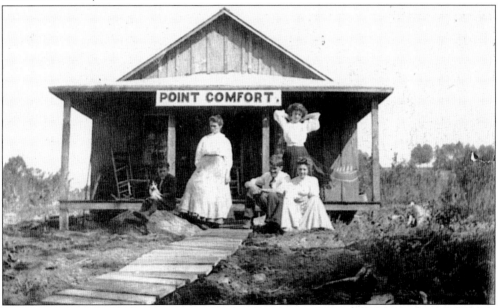

POINT COMFORT. The first mention of Point Comfort is from a local newspaper dated July 1886: "Ariel . . . Boarders are seeking recreation from the noise and heat of the city (Scranton). Prof. Plumley and family occupy the cottage on Point Comfort." The cottage was on the south shore at the end of what today is Blue Bird Lane. The site has been occupied for many years by the Schrey cottage.

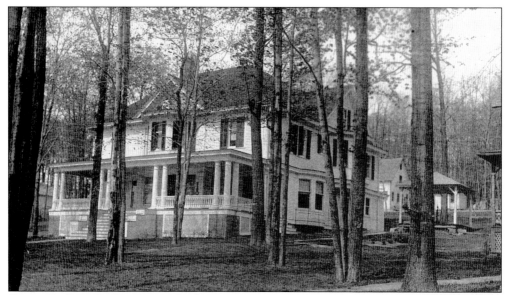

CYRUS D. JONES'S COTTAGE. The largest cottage on Lake Ariel was built by Cyrus D. Jones, who was not related to the pioneer family. Jones, the founder of the Grand Union Tea Company, was an eminent businessman in New York City and Scranton. He bought this lot on the east shore in 1894 and built this cottage, which is owned today by the McGraths. When Jones died in 1929, his was the first estate of a millionaire filed in Wayne County.

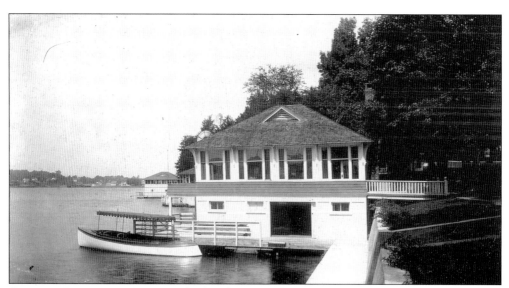

CYRUS D. JONES'S BOATHOUSE. This boathouse was built in 1894. Note the gas-powered launch next to the boathouse for Jones's pleasure.

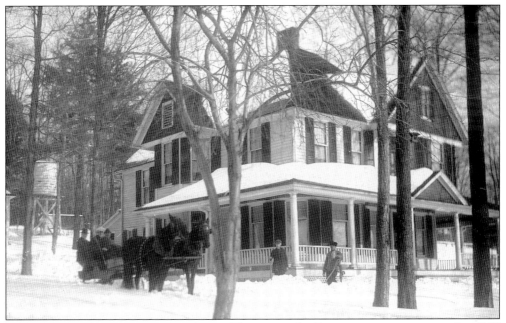

DUCKWORTH'S COTTAGE ON LAKE ARIEL. The present-day Dempsey cottage was owned in 1905 by Scranton architect John A. Duckworth. Duckworth designed the Coal Exchange Building and the Hotel Jermyn in Scranton, St. Mary's Church of Mount Carmel, St. Rose Church in Carbondale, and St. Thomas Aquinas Church in Archbald.

DUCKWORTH'S BARN. This barn stood behind John A. Duckworth's cottage, around 1905.

ORIGINAL LEVERICH COTTAGE, AROUND 1910. This cottage was built in 1888 by George Scranton Throop, youngest son of Dr. Benjamin H. Throop. In 1896, the cottage was sold to Hugh and Sarah Chesworth of Scranton. In this photograph, young Bill Leverich is standing on the front steps. At the time, Bill's father, Stewart Simpson Leverich, owned the cottage.

LEVERICH/PRUSSIA COTTAGE. Around the 1920s, Stewart Simpson Leverich tore down the 1888 Throop cottage and replaced it with the present-day building. On the right is Floyd E. Bortree's cottage, today owned by the Conways.

SWIMMERS IN FRONT OF WILLIAM KELLY COTTAGE. The Kelly cottage was built on West Shore Drive in 1889. The swimmers at the dock are, from left to right, Genevieve Kelly O'Brien (1882–1946), William Kelly's daughter, holding Genevieve O'Brien (1909–1984) and Mary Nolan Kelly (1854–1919), William Kelly's wife, holding Margaret O'Brien (1906–1980). This photograph was taken around 1910.

THE O'BRIEN COTTAGE. This cottage was built for George and Genevieve O'Brien and was completed in 1912. Genevieve was the daughter of William Kelly, who built the first cottage on Lake Ariel (Janet E. Dickinson's building is technically the oldest structure but started its life as the sawmill office). This house was later owned by Theodore Malakin and Florence (O'Brien) Malakin. This house is now owned by Theodore Malakin and Linda (Rutherford) Malakin.

THE YWCA AT LAKE ARIEL. On the site of this building was the T. J. Conway cottage, later the property of Charles H. Schadt. In 1900, Schadt let Libby Doersam use the building as a vacation rest home for low-income employed girls. Schadt deeded the property to the YWCA in October 1908.

Interior of the Y. W. C. A. Cottage, Lake Ariel, Wayne Co., Pa.

INTERIOR OF THE YWCA. The old Conway cottage was torn down in 1917, and this building was built. It accommodated 40 girls and was enlarged for 35 additional girls in the early 1920s. Note the wicker chairs around the table. This cottage is gone today.

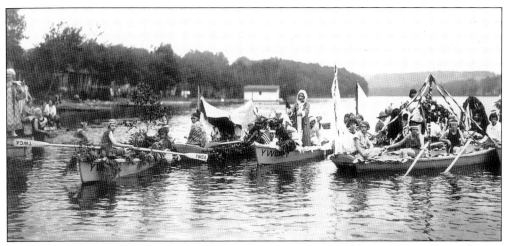

YWCA WATER PARADE. In the 1920s, the girls at the camp would have an annual grand water parade with decorated rowboats. In 1975, the camp closed and was sold to the Croces.

MOON OVER LAKE ARIEL. This photograph, by Curtis E. Jones, seems to say that the sun has set on this era of Lake Ariel's history, but the area's future will soon be the new history as it is remembered by those who follow.

ACROSS AMERICA, PEOPLE ARE DISCOVERING SOMETHING WONDERFUL. *THEIR HERITAGE.*

Arcadia Publishing is the leading local history publisher in the United States. With more than 3,000 titles in print and hundreds of new titles released every year, Arcadia has extensive specialized experience chronicling the history of communities and celebrating America's hidden stories, bringing to life the people, places, and events from the past. To discover the history of other communities across the nation, please visit:

www.arcadiapublishing.com

Customized search tools allow you to find regional history books about the town where you grew up, the cities where your friends and family live, the town where your parents met, or even that retirement spot you've been dreaming about.